Moore at Kew

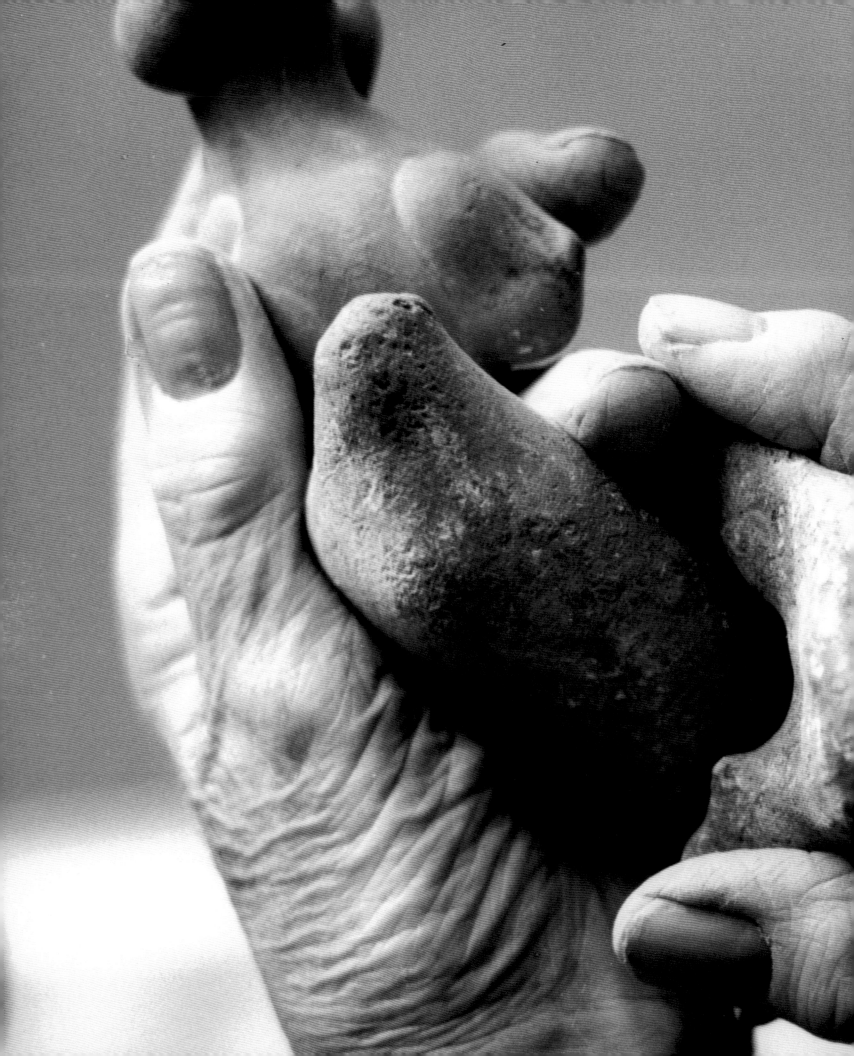

Moore at Kew

Kew Publishing
Royal Botanic Gardens, Kew

The Henry Moore
Foundation

 The Gatsby Charitable Foundation

Kew
PLANTS PEOPLE
POSSIBILITIES

Authors: Anita Feldman, Suzanne Eustace

First published in 2007 by
Royal Botanic Gardens, Kew
Richmond, Surrey, TW9 3AB, UK
www.kew.org

ISBN 978 1 84246 214 0

British Library Cataloguing in Publication Data
A catalogue record for this book is available from the British Library.

Front cover photograph: Jeff Eden
Frontispiece: The artist's hands with flints, 1978, photograph: Gemma Levine

Project Management and Production: John Harris, Lloyd Kirton
Design: Jeff Eden for Media Resources, Royal Botanic Gardens, Kew

For information or to purchase all Kew titles please visit
www.kewbooks.com or email publishing@kew.org
For other titles on Moore please visit www.henry-moore-fdn.co.uk

All proceeds go to support Kew's work in saving the world's plants for life

Printed on revive 50:50 Silk which contains 50% recovered fibre, 50% virgin fibre and is FSC certified.
Revive is available exclusively from Robert Horne Group. www.roberthorne.co.uk

Printed in the UK by BAS Printers, Romsey, Hampshire

Contents

Sculptures exhibited

Moore in Gildmore Studio,
Perry Green, 1974

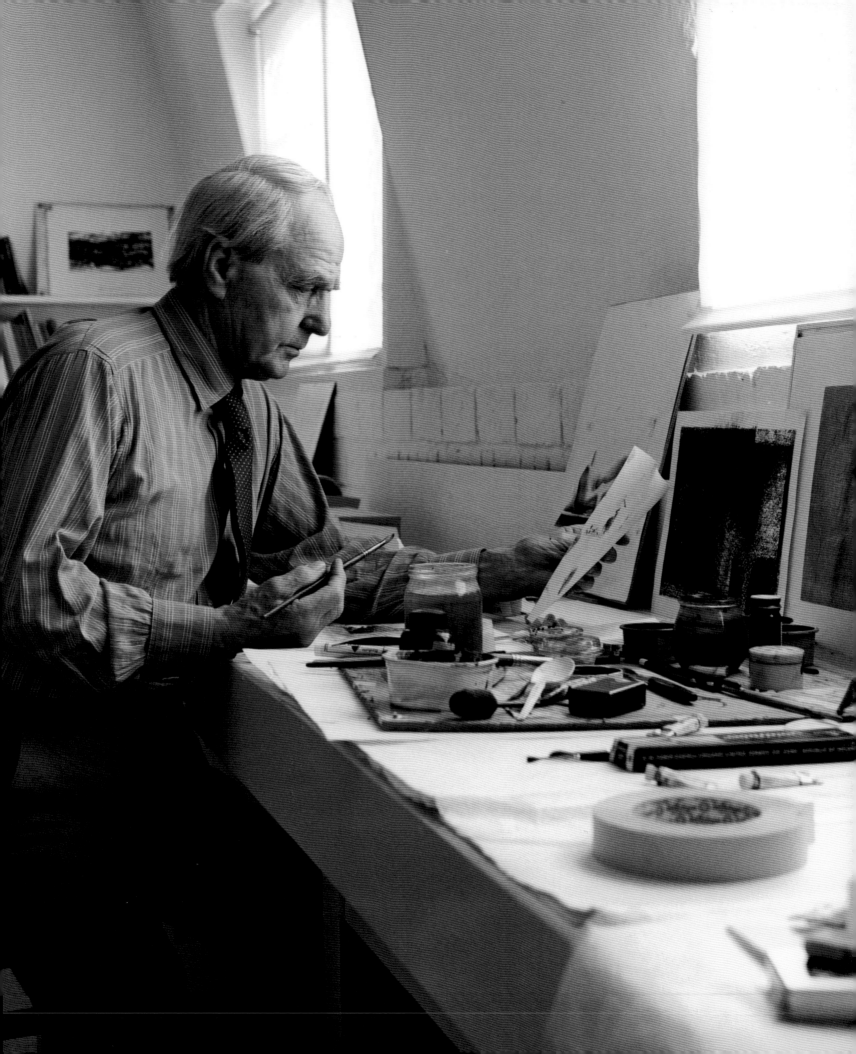

Welcome

Professor Stephen Hopper *Director, Royal Botanic Gardens, Kew*

"Observation of nature is part of an artist's life"

Moore, in *Unit One: The Modern Movement in English Architecture, Painting and Sculpture*
edited by Herbert Read, Cassell, London 1934, pp.29-30

IF ART AND SCIENCE REFLECT DIFFERENT WAYS of perceiving the world, they come together at Kew. I am proud and privileged to welcome twenty-eight monumental sculptures by Henry Moore to the Royal Botanic Gardens, Kew.

Locations mattered to Moore. A great deal of his sculpture was intended to be seen outdoors, and he thought carefully about the positioning of his work. Sculptures were sited so they could be seen to advantage from a number of angles and approaches, with a background of sky, or lawn, trees and foliage. "Sculpture is like a journey," said Moore. "You have a different view as you return."

Kew forms a perfect setting for a selection of some of Moore's finest and biggest work, not least because the Gardens themselves are constructed on a monumental scale, stretching over 300 acres on the south bank of the Thames, and containing a great diversity of the world's plants, arrayed in equally varied settings.

The traveller through Kew encounters everything from formal walled gardens and stately avenues to wildlife meadows and woods. With vistas, mature trees, open lawns and intimate spaces on offer, each sculpture can find a sympathetic niche – with which it blends, contrasts and surprises – and so stimulate us all to look at our surroundings anew, and draw strength from the natural environment.

Moore's work is perfect for Kew too because it is wonderfully accessible, appealing to people of all ages and walks of life. Throughout his life, Moore collected bones, driftwood, shells and stones, especially flints, finding inspiration in their organic forms, but it might just as easily have been seeds or tree trunks. He particularly loved to draw the skeletal form of winter trees, and they were among his favourite natural subjects.

For, as he once remarked, a sculptor is a person who is interested in the shape of things. Botanists too attend to the shape of living forms, with an intensity and seriousness of purpose that Moore would surely have approved of.

As landscape and the natural world inspire art, we come full circle, reconnecting with the green kingdom that forms the basis of all life. I hope that the chance to see so many of Moore's sculptures together for the first time will draw visitors to Kew who might think they "don't do" gardens or nature – and yet find much to enjoy. I hope too that visitors will return again and again to see the sculptures in changing light and colour and atmosphere, and come to appreciate Kew's richness and diversity through the seasons. Flowering, fruiting, growing, resting – the annual cycle of life unfolds at Kew, reflected in thousands of extraordinary plant life histories.

Above all, I hope a visit to Kew will provide an opportunity to reflect on what we all need to do to safeguard the future of the planet's irreplaceable botanical inheritance, and to minimise our impact on its increasingly threatened life-support systems.

Professor Stephen Hopper

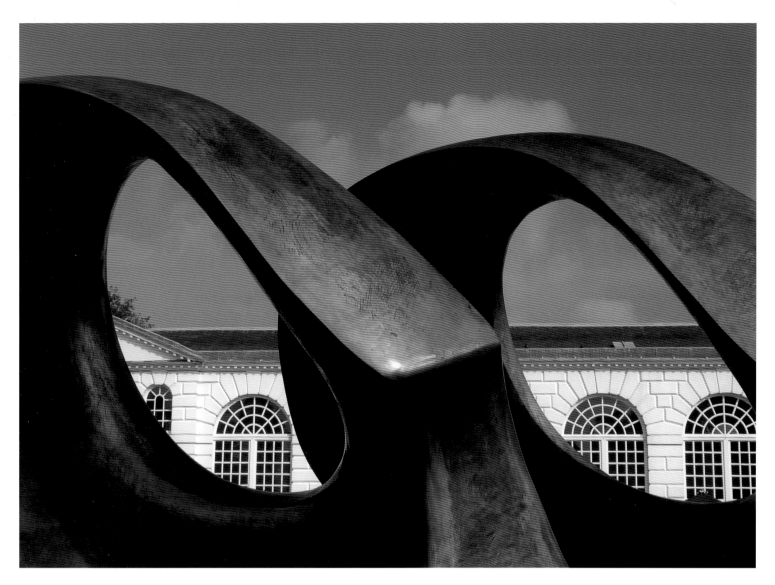

Double Oval at the Royal
Botanic Gardens, Kew

For Kew is much more than one of the world's finest showpiece gardens. It's also a global centre for research on plants and fungi, with an international reputation for scientific excellence in everything from plant identification and forensics to seed banking and medicinal plants. What's more, it's a site of World Heritage, rich in history and with the Earth's largest botanical and horticultural collections in its care.

Increasingly, Kew is reaching out across the world in partnerships with other organisations aiming to conserve plant life and chart a way forward that ensures a sustainable future for plants and people. Meanwhile, we're busy minding our own backyard, composting waste, mulching to conserve water, using natural pest control – trying to practise what we preach.

We hope visitors to the Henry Moore exhibition will find inspiration here, and ideas of ways that everyone can help in caring for the living world of which we are a part, and in which we are embedded. A little effort by a lot of people will make all the difference, but the challenge we face is to make that happen. Hosting these impressive works of art at Kew can only further that transformation. As Henry Moore commented in 1964: "One of the things I would like to think my sculpture has is a force, is a strength, is a life…It's as though you have something trying to make itself come to a shape from inside itself."

Foreword

Richard Calvocoressi *Director, The Henry Moore Foundation*

THE LAST FEW YEARS HAVE SEEN a renewed interest in Henry Moore's work. Important exhibitions – retrospectives as well as smaller, more focused shows examining different aspects of Moore's rich and varied achievement – have taken place in Japan, New Zealand, Brazil and the USA. In Europe two exhibitions were held in Athens during the 2004 Olympic Games, and in 2005 a group exhibition held at Schwäbisch Hall in Germany demonstrated Moore's influence on younger British sculptors such as Tony Cragg, Richard Deacon, Antony Gormley and Anish Kapoor.

Last year two exhibitions initiated and curated by the Henry Moore Foundation, the first examining the effect of the war on Moore's work and the second exploring his relationship to architecture, were shown in London and Rotterdam respectively. This year the Foundation's exhibition on Moore and landscape travels to Berlin and Frankfurt, while that on Moore and mythology goes to Paris.

It takes time for an artist's late work to be evaluated and accepted. With artists who are also major public figures, such as Moore, closely involved in the interpretation and promotion of their own work, their disappearance from view leaves a void which is not easily filled. The present exhibition in Kew Gardens, consisting of large-scale bronzes (and one fibreglass piece) from the last three decades of the artist's life, is the first substantial exhibition of Moore's outdoor works to be held in London since 1978. It offers visitors a wonderful opportunity to experience the monumental sculptures in the kind of setting the artist favoured – in direct contact with nature. In this it differs from the last retrospective exhibition held in London, the memorial show at the Royal Academy in 1988, and the more recent exhibitions at Dulwich Picture Gallery and the Imperial War Museum.

Of the twenty-eight sculptures on display at Kew, twenty-six come from the collection of the Henry Moore Foundation, several from long-term display at the Foundation's headquarters at Perry Green, a hamlet near Much Hadham in Hertfordshire, about 30 miles north of London. This means that, for the duration of the exhibition, the gardens and fields at Perry Green will contain fewer works than usual. However, this is more than compensated for by the opening to the public earlier this year of Moore's home, Hoglands, where the artist lived from 1940 until his death in 1986.

When the Foundation was set up by Moore in 1977, he gifted to it a significant body of his own work in all media – as well as the copyright to it – and all preparatory material such as found objects, maquettes and sketchbooks; in addition he donated property, investments and other assets. The Foundation therefore owns a large collection of works of art, mainly by Moore, comprising the entire graphic work; some thousands of drawings; numerous sketchbooks; about eight hundred sculptures, varying in size from small to monumental; archives and library; and Moore's studios surrounded by some seventy acres of land. It has recently added the Sheep Field Barn galleries to provide space for a changing programme of exhibitions.

Income from the Foundation's investments is used to further its stated aim, which is 'to advance the education of the public by the promotion of their appreciation of the fine arts, and especially the work of Henry Moore'. To this end it's resources are applied in three main areas. From the artist's estate at Perry Green flows a continuous

Richard Calvocoressi

Moore with the plaster for
Double Oval

programme of loans, exhibitions, guided visits, publications and conservation, carried
out by a dedicated team of curatorial, archival and administrative staff. At Leeds in
Yorkshire, where Moore studied at art college from 1919–21, the Henry Moore
Institute, through its own innovative programme of exhibitions, artist-in-residence
schemes, conferences and publications, looks at sculpture from a broader perspective,
not confined to Moore or indeed to work of any particular culture or historical period.
The Institute works in partnership with Leeds City Art Gallery and with Leeds University
on certain specific projects and also houses a growing archive of British sculpture.
Finally, through its Grants Programme, the Foundation supports activities in art colleges,
universities, museums and galleries – from research to publications, from workshops to
exhibitions. In 2006 it provided just over £1 million in grants.

I hope that visitors to this exhibition at Kew will gain an insight into the subjects and
forms that moved Moore to create his sculptures – themes which, as human beings, we
can all share. I also hope that the exhibition will give visitors cause to reflect for a moment
on Moore's legacy. Although artists' foundations are common in the USA, what Moore
did was unique in this country, certainly on such a scale. The Henry Moore Foundation is
committed to ensuring that Moore's work remains relevant for a younger generation as
well as to helping make possible a wide range of projects in the visual arts.

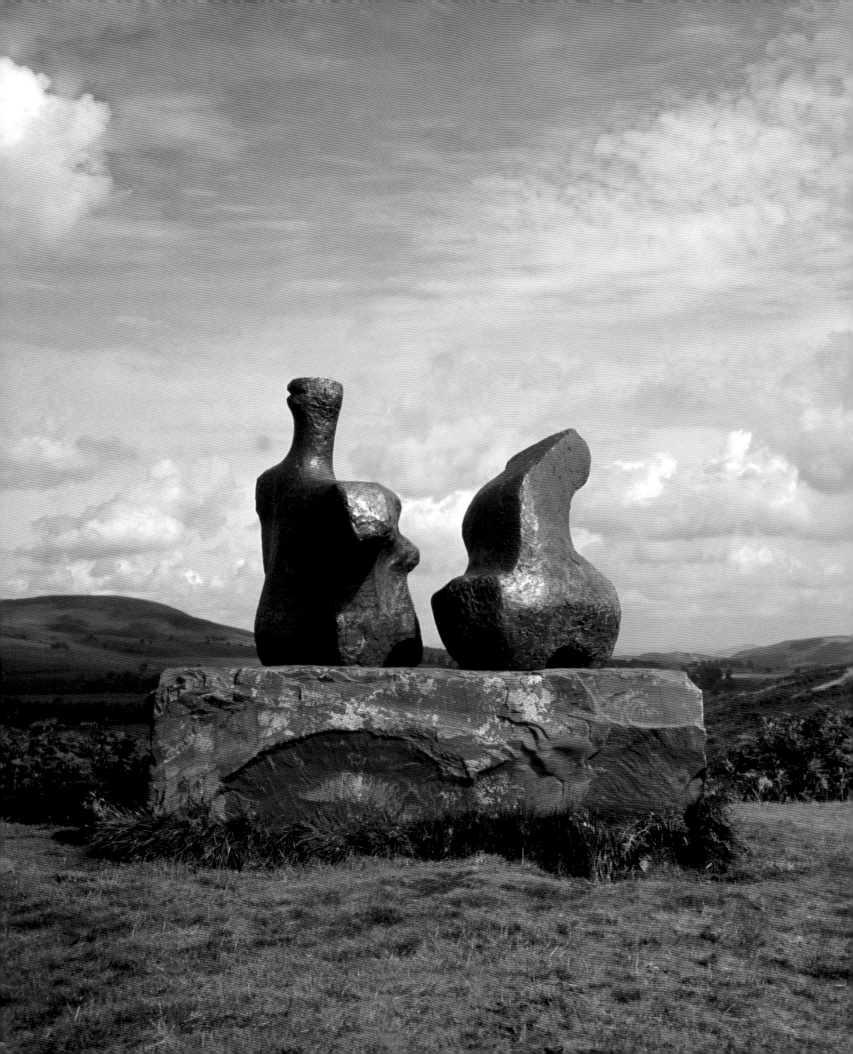

An art of the open air

Anita Feldman *Curator, The Henry Moore Foundation*

"Sculpture is an art of the open air. Daylight, sunlight, is necessary to it, and for me its best setting and complement is nature. I would rather have a piece of my sculpture put in a landscape, almost any landscape, than in, or on, the most beautiful building I know."[1]

MOUNTING A MAJOR INSTALLATION of Moore's sculpture in the gardens at Kew instantly provokes a number of questions concerning the increasing popularity of outdoor sculpture displays, Moore's engagement with landscape and natural forms in his sculpture, and the artist's reputation in Britain.

Due to logistical complications and considerations of security and expense, major temporary displays of outdoor sculpture are rare. The last exhibition of Moore's open-air sculpture in the UK was held at the Yorkshire Sculpture Park in 1987, a year after the artist's death.[2] The only other outdoor display of his work in the UK was held at the Serpentine Gallery in London as long ago as 1978. Although this exhibition is well remembered, particularly for the impressive travertine marble arch which Moore presented to Kensington Gardens following the immense success of the show,[3] the works largely consisted of indoor sculpture, with just nine pieces sited in the park. In contrast, this exhibition at Kew affords a selection of twenty-eight outdoor sculptures, all monumental in scale as well as in concept. Other open-air displays of Moore's work have been held in Paris at the Bagatelle Gardens in 1992 and at the Hakone Open-Air Museum in 2004. Smaller, but nonetheless spectacular, outdoor displays were held in the cities of Luxembourg in 1999 and in Schwäbisch Hall and Brasilia in 2005.

To put this in perspective one needs to consider that the first sizeable open-air sculpture exhibition in Britain (and by all accounts in the world) was held in Battersea Park, London, in 1948. This included Moore's **Three Standing Figures** 1947 (LH 268) in Darley Dale stone which is still sited in the park,[4] as well as **Recumbent Figure** 1938 (LH 191) in brown Hornton stone.[5] Two years later Europe's first sculpture park – as opposed to a temporary installation – was established in Middelheim just outside Antwerp, with a cast of Moore's **King and Queen** 1952–53 (LH 350) as one of their first acquisitions. Perhaps the most innovative siting of sculpture in the open air was achieved at the Glenkiln estate in Dumfries, where **King and Queen, Standing Figure** 1950 (LH 290), **Upright Motive No.1: Glenkiln Cross** 1955–56 (LH 377) and **Two Piece Reclining Figure No.1** 1959 (LH 457) are dramatically sited in the wilds of the Scottish landscape (fig. 1). Today there are over 133 sculpture parks in Europe alone.[6] These have sprung up almost exclusively in the last two decades. The growing demand for outdoor sculpture is seemingly without bounds.

This exhibition is not a retrospective. It was not until the aftermath of the Second World War, when Moore was already fifty, that he began creating sculpture intended for siting in the landscape, although he had worked in the open air throughout his career. One of his earliest sculptures, the alabaster **Dog** of 1922 (LH 2), was carved out of doors,

fig. 1
Two Piece Reclining Figure No. 1 1959 (LH 457), Glenkiln Estate, Dumfries

[1] Moore interviewed in *Sculpture and Drawings by Henry Moore*, Tate Gallery, London 1951, p.4.

[2] Changing displays of Moore's work have been maintained at the Yorkshire Sculpture Park since 1994.

[3] **The Arch** 1979–80 (LH 503c) was donated by the artist to the Department of the Environment (now Royal Parks) and removed from display years later in the interest of public safety. It is currently undergoing structural analysis with a view to restoration. Ironically, the travertine marble was chosen by Moore as a material more suitable for permanent open-air siting than the fibreglass cast which was in the exhibition.

[4] The sculpture was intended for the Museum of Modern Art in New York, but the Contemporary Art Society offered it to Battersea Park; MOMA later acquired **Family Group** 1948–49 (LH 269) in bronze instead.

[5] Now in the Tate collection, this carving was originally made for the garden of Serge Chermayeff, who left Britain for the United States at the outbreak of war. The sculpture was intended as a mediator between modern architecture and landscape.

[6] See Jimena Blázquez Abascal, *Sculpture Parks in Europe: A Guide to Art and Nature*, Birkhäuser, Basel, Boston and Berlin 2006, p.5. This figure does not include what the author refers to as 'public art projects of dubious quality, realized in both urban and green spaces . . . ' p.12.

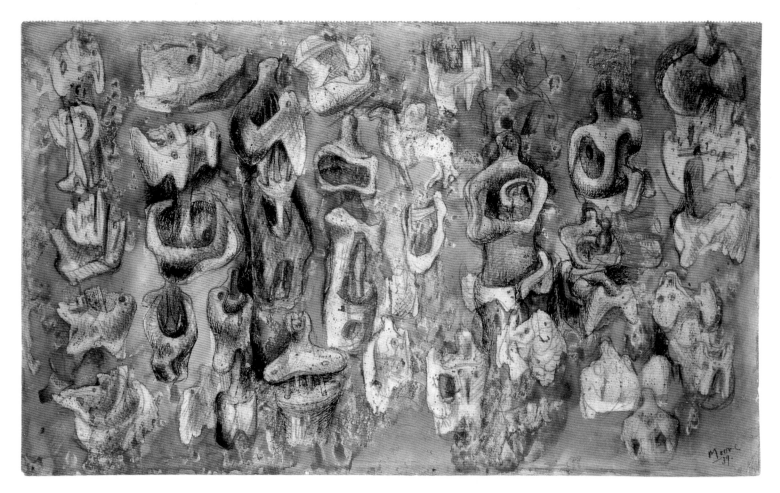

fig. 2
Studies for Sculpture in Various Materials
1939 (HMF 1435)

and from the mid-1930s Moore and his wife Irina kept a cottage in the Kent countryside to enable him to carve outside, surrounded by hills and valleys. The theme of this installation naturally excludes a vast amount of material – it does not embrace the artist's smaller scale works, carvings or works on paper, let alone textiles or tapestries, although some of this material is treated in the educational display in the Nash Conservatory. Yet among the works shown outside at Kew all of Moore's major themes are present: reclining figures, mother and child, organic forms, internal/external forms, interlocking forms and figure as landscape. There is also an array of surface treatments, from smooth polished areas to those that are highly textured, from the stark white of fibreglass to bronze patinas of rich brown, gold, black and vivid green.

While viewing these sculptures it is important to keep in mind that they each started out as a clay or plaster maquette small enough to be held in the palm of the artist's hand and imagined any size. When he returned to making sculpture after the war, Moore found that using small three-dimensional models or 'maquettes' enabled him to work out an idea more fully in the round than through creating numerous sketches. This is not to imply that he ceased drawing – his drawings

alone fill a seven volume catalogue raisonné – but the separation of his drawings from practical sculptural investigations meant that when drawing he could experiment more freely with colour and non-sculptural ideas, as well as studying in different ways sculptures that he had already made. The creation of sculptural maquettes was, however, Moore's main activity. That he enlarged less than one in ten maquettes is seldom acknowledged. Far from wanting to make everything big, he was very aware that there was a right size for every idea. Furthermore, he firmly believed that a work could embody a sense of monumentality without necessarily being large in scale. Thus more representational, figurative work tended not to be enlarged over life size; colossal works such as **Large Upright Internal/External Form** 1981–82 (LH 297a), **Oval with Points** 1968–70 (LH 596) and **Large Spindle Piece** 1974 (LH 593) are tough abstract works that can hold their own in any setting, whether landscape or architectural.

Lending to the universal appeal of Moore's sculpture is the fact that his figures are not recognisable as individuals: they remain anonymous. With timeless, outward gazes they appear to question the nature of mankind itself in relation to its environment. Even the

seemingly abstract works are derived from the natural world, inspired by the curvature of a bone, the texture of driftwood, internal coils of a sea shell or smooth pointed shapes of flints found in the fields surrounding Moore's Hertfordshire home. It is the artist's life-long exploration of natural forms that makes Kew, with its immense array of varied foliage throughout the changing seasons, so perfectly suited to his outdoor work.

A simple inscription from one of Moore's earliest notebooks anticipates his use of natural forms: 'remember pebbles on the beach' is pencilled on the cover of a 1926 sketchbook.[7] In his transformation drawings a few years later, and in more heavily worked compositions at the end of the decade, found objects such as stones, bones and shells metamorphose into human figures (fig. 2). But it was not until the 1950s that Moore began to manipulate these forms in his sculpture. His monumental bronzes are still perceived as icons of art in landscape, not least because Moore is considered the first sculptor to have created work specifically for siting in the open air, as opposed to garden statuary, public monuments or memorials.[8] In the traumatic aftermath of the Second World War, in which a quarter of Britain's capital city lay in ruins and rationing continued well into the subsequent decade, new approaches to public sculpture were needed. Particularly through their siting in recently rebuilt towns, Moore's family groups, reclining figures and mother and child sculptures were imbued with a civic purpose – renewing community spirit and projecting a sense of continuity with the past as well as optimism for the future.

Twenty years later, when the majority of these works at Kew were created, Moore laid aside the social role of the artist to follow a vision that was intrinsically more personal and independent of the avant-garde. He found inspiration from nature at a time when that was not highly regarded. Critics such as Clement Greenberg who held dominion over the tide of abstract expressionism, minimalism and conceptual art, abhorred any reference to naturalism and openly denounced Moore.[9] The changes in Moore's approach to sculpture coincided with dramatic changes in his living circumstances. From the early 1930s Moore had lived in the unparalleled artistic milieu of Hampstead, where his neighbours included many artists, architects and intellectuals driven to England by the rise of fascism in Europe, among them Naum Gabo, Piet Mondrian, Walter Gropius, ELT Messens and Marcel Breuer, in addition to British friends such as Julian Huxley, Barbara Hepworth and Ben Nicholson. They would exchange ideas at the local Isobar, in the Isokon building, a triumph of the new sleek modernist architecture

designed by the Canadian Wells Coates and run by the modern furniture industrialist Jack Pritchard, who helped many Bauhaus refugees enter Britain. All this was cut short by the outbreak of war in September 1939. Bomb damage to the Moores' house and studio in 1940, coupled with forced evacuation of their cottage in Kent, led Moore and Irina to move to the Hertfordshire countryside (within easy reach of London), where they remained for the rest of their lives.

It was in Perry Green, surrounded by open fields, a medieval wood and apple orchards, that Moore created the works inspired by nature that are so compatible with the diverse gardens of Kew. Here he would unearth flintstones from the ploughed land, animal bones from the sheep fields and former pig sties, and study the tangled roots of ancient trees. His 'library of natural forms', which was how he sometimes referred to his maquette studio, soon filled with a variety of shapes and textures that would inform his sculptures. He observed:

I have always been very interested in landscape. (I can never read on a train – I have to look out of the window in case I miss something.) As well as landscape views and cloud formations, I find that all natural forms are a source of unending interest – tree trunks, the growth of branches from the trunk, each finding its individual air-space, the texture and variety of grasses, the shape of shells, of pebbles, etc. The whole of nature is an endless demonstration of shape and form; it always surprises me when artists try and escape from this.[10]

It is this aspect that increasingly set Moore apart from his contemporaries and continues to be recognised and appreciated today. As recently as 1999 the Belgian sculptor Ludo Bekkers wrote:

During the war and the years of occupation, I had no access whatsoever to information about what was happening in modern art elsewhere in the world. Shortly after liberation, the names and the works of artists who were opening up new horizons began to emerge . . . Anything that was even slightly out of line with traditional sculpture was quickly associated with [Moore's] name . . . So there must have been a factor in Henry Moore's work, which though considered 'modern' nevertheless had a general appeal. Could the organic origin and the reference to natural forms which are an inherent part of much of Moore's works, have been responsible?[11]

[7] **Notebook No. 6**. 1926 The Henry Moore Foundation: gift of the artist 1977.

[8] A possible exception is Brancusi's 1938 *Endless Column* in Targu-Jiu, Romania.

[9] See Clement Greenberg, 'Arrogant Purpose', *Collected Essays and Criticism*, vol. 2, 1944–49, University of Chicago Press, Chicago 1986, pp.126–7.

[10] *Henry Moore: Energie im Raum*, Bruckmann, Munich 1973, p.19.

[11] Ludo Bekkers, 'Henry Moore: A Review', *Henry Moore Sculpturen/Tekeningen*, Openluchtmuseum voor Beelhouwkunst Middelheim, Museum van Hedendaagse Kunst, Antwerp 1999, p.9.

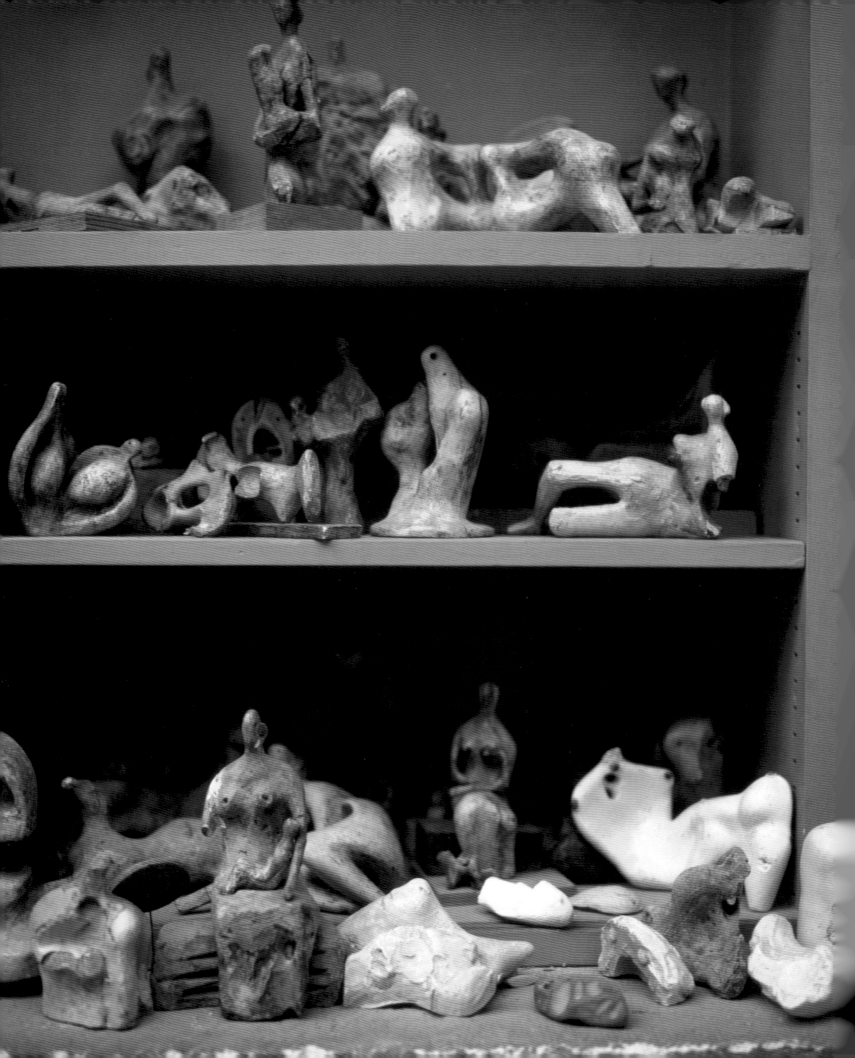

fig. 3
Bourne Maquette Studio,
Perry Green

fig. 4
The Woolpacks,
Kinder Scout, Derbyshire,
from Moore's
photographic collection

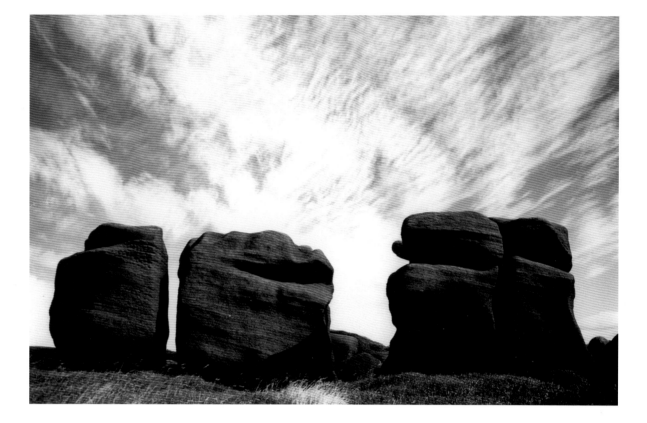

It is not simply the organic forms, however, that make this connection between man and nature in Moore's sculpture so complete. There is also an element of time: as one approaches from a distance and walks around a sculpture, both landscape and sculpture reveal themselves gradually. Weather, light and shifting vistas are all part of the ever-changing experience. Moore's interest in landscape was not new; he had for over thirty years been looking at the female form as a metaphor for the earth. As early as 1930 he stated:

> 'The sculpture which moves me most is full blooded and self-supporting, fully in the round, that is, its component forms are completely realised and work as masses in opposition . . . it is not perfectly symmetrical, it is static and it is strong and vital, giving out something of the energy and power of great mountains.'[12]

In this vein, Moore uses the versatility of bronze to open out the figure, or fragment it to take on the appearance of the land, thus completing a process of transformation.

Anyone who has ventured into the artist's studios at Perry Green realises that there is still much to unearth, that the familiar bronzes in urban sites do not reveal the whole story. At the edge of a windswept sheep field, Moore's tiny maquette studio can be found; an old wicker chair, cane and turntable are positioned at its core, with cardboard boxes on the floor full of flintstones and plaster odds and ends. In a cupboard plastic bowls contain tiny plaster heads and fragments of arms and legs. Lining all the walls are shelves crammed full of animal bones, flints, sea shells, pebbles and gnarled bits of driftwood, all intermingled with ideas for sculpture at various stages of completion. Here, the forms of man and nature become strangely indistinguishable from each other (fig. 3). There is often an unsettling ambiguity that results from natural forms carefully arranged in human form.

Viewing Moore's sculpture against the rugged hills of Yorkshire, in the pastoral fields of Perry Green or the ever-changing gardens of Kew, it is immediately apparent that there is a fundamental harmony between sculpture and landscape, an elemental bond between man and nature. With Moore, however, nature is not always nurturing; there is often a tendency to sublimate the human aspect – for the figure to be fragmented and ultimately overpowered, twisted, or consumed by forces beyond human control. By emphasising the power of nature, Moore simultaneously increases the viewer's awareness of

[12] Henry Moore 'A View of Sculpture', originally published as 'Contemporary English Sculptors: Henry Moore', *Architectural Association Journal*, May 1930, p.408; reprinted in Alan Wilkinson, *Henry Moore: Writings and Conversations*, Ashgate, Aldershot 2002, p.188.

[13] For example the landscapes of Joseph Mallord Turner (1775–1851), John Martin (1789–1854) and James Ward (1769–1859), in which figures or animals are overwhelmed by the forces of nature.

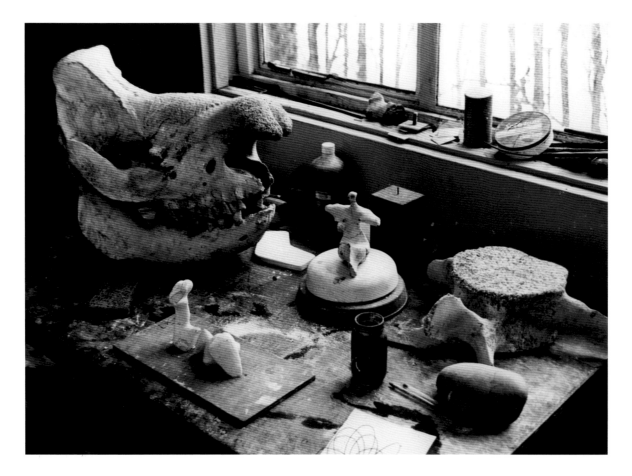

fig. 5
Rhinoceros skull in Moore's studio with; centre: plaster **Maquette for Seated Woman with Arms Outstretched** 1960 (LH 463); right: whale vertebrae; foreground: plaster **Maquette for Two Piece Reclining Figure: Cut** 1978 (LH 755) on grid to be scaled up for enlargement

fig. 6
Moore in his maquette studio with the skull of an African elephant and plaster **Maquette for Reclining Connected Forms** 1969 (LH 611)

the fragility of mankind. This is a quality we are more accustomed to associating with British painting, particularly the great dramatic landscapes of the nineteenth century.[13] Moore was the first artist to explore the power of sculpture to convey this idea, and this is one of his unique contributions to the sculpture of the twentieth century.

Photographs of rock formations were used as a catalyst for some ideas, particularly the two and three piece reclining figures and forms separated by tense, narrow chasms such as **Two Piece Reclining Figure: Points** 1969–70 (LH 606) (fig. 4). Local flintstones became the genesis of works such as **Large Spindle Piece** 1968–74 (LH 593), while seed pods can be detected as the source of **Seated Woman** 1958–59 (LH 440) and **Large Totem Head** 1968 (LH 577). Bones provided some of the most inspired ideas for the artist. Moore had innumerable bones in his collection. These ranged from the tiniest bones of birds to fragments of animal jaws, entire skulls including those of a black rhinoceros, an African elephant and even the vertebrae of a Minky whale (fig. 5). Moore wrote:

'By bringing the [elephant] skull very close to me and drawing various details I found so many contrasts of form and shape that I could begin to see in it great deserts and rocky landscapes, big caves in the sides of hills, great pieces of architecture, columns and dungeons . . . '[14]

Works such as **Reclining Connected Forms** 1969 (LH 612) reveal this interest, with one form cupped and socketed within another (fig. 6), while **Large Standing Figure Knife Edge** 1961 (LH 482a) and **Knife Edge Two Piece** 1962–65 (LH 516) manipulate the contrast between the sharp 'knife-edge' of a bone and other smooth and highly textured areas.

Large Reclining Figure 1983 (LH192b) stands apart from the other works due to its less directly organic but rather more biomorphic forms. That is to say, the forms, like those of a Jean Arp sculpture or Joan Miró painting, have a fluid, amorphous quality more characteristic of the Surrealists and their exploration of transformation and metamorphosis. This is explained by the fact that the sculpture was enlarged as late as

[14] Moore's typed notes from 1970 referring to his studies of an elephant skull. The Henry Moore Foundation Archive; published in Wilkinson, op.cit., pp.297–8; reprinted in Alan Wilkinson, *Henry Moore: Writings and Conversations*, Ashgate, Aldershot 2002, p.188.

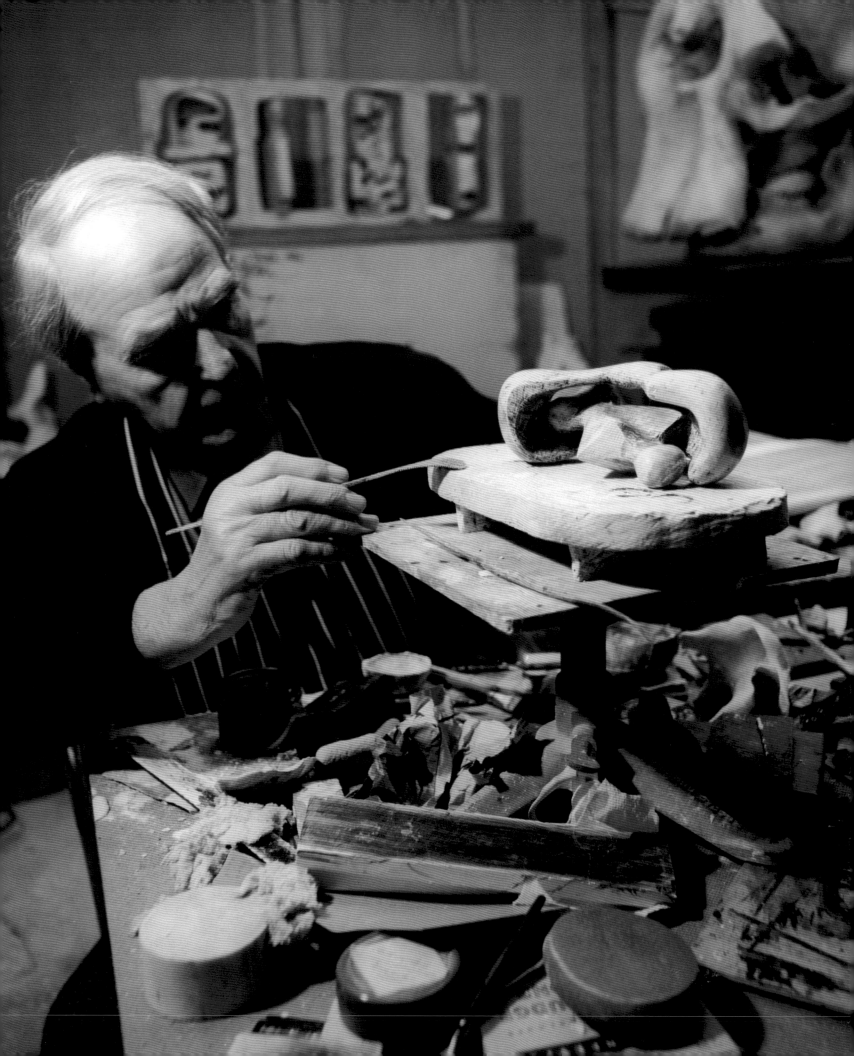

1983 from a 1938 maquette. The original sculpture in lead was a mere 33 centimetres long. Not even the wild imaginations of the Surrealists could envision it being cast half a century later on such a monumental scale, although in the 1930s Moore had photographed the maquette against the sky and hills of the Kent countryside to make it appear colossal (fig. 7). An enlargement of the maquette selected by Moore and the architect IM Pei was created for a site in Singapore, and Moore used his artist's copy for a site at Perry Green on top of a large hill at the end of the sheep field, where the work benefited from being viewed in silhouette. As nearly all Moore's sculpture was intended to be experienced fully in the round, there were few other possibilities for the site. The white fibreglass cast was made in order to have a version suitable for inclusion in exhibitions, its lightweight structure being more easily transportable. The siting at Kew allows the distinct white forms to be seen against the elegant iron tracery of the Palm House, as well as the contrasting formal garden around the reflecting pond.

The fact that Moore's sculptures were conceived for landscape made it difficult for the artist to reconcile that increasingly his works were finding homes in an urban environment. This led him in the 1950s to experiment with architectural references in sculpture, particularly whilst grappling with a major commission for the UNESCO headquarters in Paris designed by Marcel Breuer. The result was a series of sculptural ideas incorporating figures with seats, platforms, benches, stairs or walled backgrounds. **The Wall: Background for Sculpture** 1961 (LH 483) was one such experiment. Moore tried out several sculptures against this background, including **Standing Figure: Knife Edge** made the same year (LH 482 height 284.5cm, enlargement displayed at Kew cast 1979), only to conclude that they looked better without it.

The upright motive series, of which four are included here, similarly stem from architectural rather than landscape pursuits. Although the idea for the series is frequently linked to a proposed project for the Olivetti Headquarters in Milan, the first upright motives were created in 1954 in collaboration with the architect Michael Rosenauer for the site of the new English Electric Company headquarters on the Strand, in London.[15] The idea was to integrate

fig. 7
Lead maquette for
Reclining Figure 1938
(LH 192) photographed
by Moore outside his
cottage in Kent

[15] The proposed structure was never built as Rosenauer lost the commission to Gordon Tate, although a similar concept was carried out for the site of the Time/Life Building on Bond Street also designed by Rosenauer with a pierced screen by Moore in Portland stone.

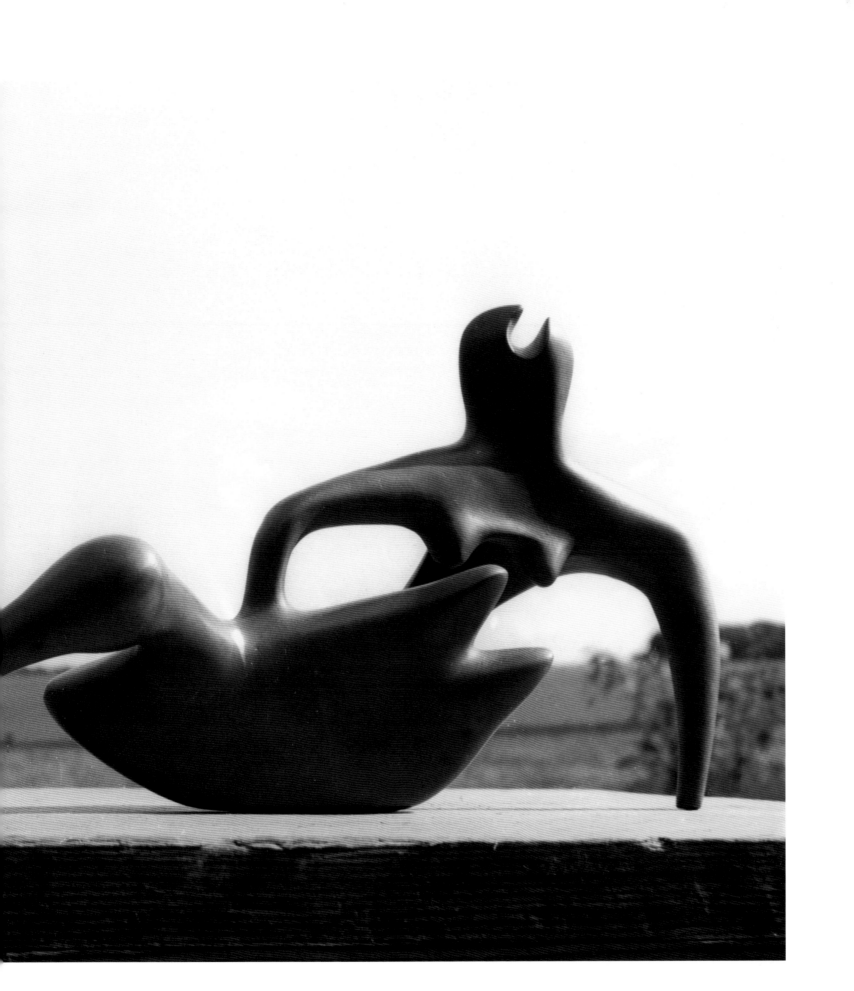

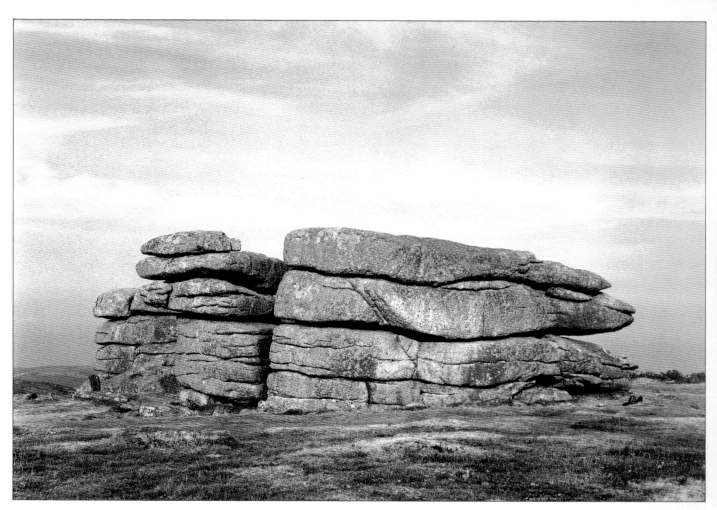

COMBESTONE TOR

A HUNDRED TORS IN A HUNDRED HOURS

A 114 MILE WALK ON DARTMOOR

YES TOR	WINTER TOR	GREAT MIS TOR	HUNTER'S TOR	FOX TOR
BLACK TOR	EAST MILL TOR	CONIES DOWN TOR	RAVEN'S TOR	SOUTH HESSARY TOR
SHELSTONE TOR	OKE TOR	LYDFORD TOR	HOUND TOR	KING'S TOR
SOURTON TOR	STEEPERTON TOR	BEARDOWN TOR	HONEYBAG TOR	VIXEN TOR
GREAT LINKS TOR	HOUND TOR	LITTAFORD TOR	CHINKWELL TOR	FEATHER TOR
BRAT TOR	WILD TOR	LONGFORD TOR	BELL TOR	HECKWOOD TOR
DOE TOR	WATERN TOR	HIGHER WHITE TOR	HOLWELL TOR	PEW TOR
GER TOR	RIVAL TOR	CROW TOR	HAYTOR	INGRA TOR
NAT TOR	KESTOR ROCK	ROUGH TOR	SADDLE TOR	LEEDEN TOR
HARE TOR	THORNWORTHY TOR	DEVIL'S TOR	RIPPON TOR	HART TOR
SHARP TOR	SITTAFORD TOR	FLAT TOR	TOP TOR	BLACK TOR
CHAT TOR	FUR TOR	LOWER WHITE TOR	PIL TOR	SHARPITOR
GREEN TOR	LYNCH TOR	HARTLAND TOR	HOLLOW TOR	LEATHER TOR
KITTY TOR	BAGGA TOR	STANNON TOR	WIND TOR	DOWN TOR
LINTS TOR	WHITE TOR	BIRCH TOR	CORNDON TOR	COMBESHEAD TOR
DINGER TOR	ROOS TOR	HOOKNEY TOR	YAR TOR	CALVESLAKE TOR
WEST MILL TOR	COX TOR	HAMELDOWN TOR	COMBESTONE TOR	HARTOR TOR
ROWTOR	GREAT STAPLE TOR	KING TOR	HUCCABY TOR	GUTTER TOR
BELSTONE TOR	MIDDLE STAPLE TOR	SHAPLEY TOR	LAUGHTER TOR	HEN TOR
HIGHER TOR	LITTLE MIS TOR	EASDON TOR	BELLEVER TOR	GREAT TROWLESWORTHY TOR

DEVON ENGLAND 1976

"I am by nature a stone-carving sculptor, not a modelling sculptor. I like chopping and cutting things, rather than building up. I like the resistance of hard material. At one time I used to think that a stone sculpture was superior to modelling, but I don't think so any more, since it is the quality of the final result which counts, no matter how it is made. Even now, in producing my bronzes, the process that I use in making the plaster original is a mixture of modelling and carving."

John Hedgecoe (ed.), Henry Spencer Moore, Nelson, London 1968, p.447

sculptural elements within the concept of the building itself, rather than merely create work which would adorn an otherwise completed building. Moore's sculptures successfully unify a mixture of organic and industrial elements into one coherent design. At Kew, the sculptures are arranged on a series of plateaux of alternating heights against the architecture of the Princess of Wales Conservatory.

Later sculptures such as **Large Two Forms** 1966-69 (LH 556) and **Hill Arches** 1973 (LH 636) take on architectural characteristics by the very fact that they are able to be entered physically. They are tough, bold forms that can hold their own against any setting, even the most elaborate architectural background such as the Karlskirche in Vienna, where a cast of **Hill Arches** is sited in the pool outside, its orb and contrasting diagonal forms echoing the baroque architectural features of the church. When placed in the landscape, however, the open forms of the arches create apertures which alter one's view of the surrounding area – vistas are ever-changing as one walks through and around the forms. They are particularly good pieces for Kew in which to observe sculptural form within the changing light and foliage throughout the seasons.

There is a connection psychologically with Moore's practice of extracting found objects from the earth and returning them to the landscape as pieces of sculpture. His sculptures often convey a sense not only of timelessness, but of mystery – as if we have always known them and yet they will forever retain a sense of discovery.

fig. 8
Richard Long, *A Hundred Tors in a Hundred Hours / a 114 Mile Walk on Dartmoor/Devon England 1976*

Moore explained:

The whole of nature – bones, pebbles, shells, clouds, tree trunks, flowers – all is grist to the mill of a sculptor. It all needs to be brought in at one time. People have thought – the later Greeks, in the Hellenistic period – that the human figure was the only subject, that it ended there; a question of copying. But I believe it's a question of metamorphosis. We must relate the human figure to animals, to clouds, to the landscape – by bringing them all together. There's no difference between them all. By using them like metaphors in poetry, you give new meanings to things.[16]

Jacquetta Hawkes expounded a similar connection between landscape, art and archaeology in *A Land*, published – with illustrations by Moore – on the occasion of the 1951 Festival of Britain:

I have used the findings of the two sciences of geology and archaeology for purposes altogether unscientific. I have tried to use them evocatively, and the image I have sought to evoke is of an entity, the land of Britain, in which past, present, nature, man and art appear all in one piece. I see modern men enjoying a unity with trilobites of a nature more deeply significant than anything at present understood in the process of biological evolution; I see a land as much affected by the creations of its poets and painters as by changes of climate and vegetation.[17]

The tradition of placing objects where they will render meaning to both the object and the chosen site is, of course, a prehistoric one. Since Moore, investigation of the relationship between man and environment continues in the work of British artists such as Ian Hamilton Finlay (1925–2006), Richard Long (b.1945), Hamish Fulton

[16] Carlton Lake, 'Henry Moore's World', *Atlantic Monthly*, Boston January 1962, p.42; cited in Wilkinson, op.cit., p.222.

[17] Jacquetta Hawkes, preface to *A Land*, Cresset Press Ltd, London 1951.

(b.1946) and Andy Goldsworthy (b.1956), all of whom use found objects and local stone to convey a sense of man's intervention with the earth. Long's *A Hundred Tors in a Hundred Hours / a 114 Mile Walk on Dartmoor / Devon England 1976* uses photography to document a journey marked by outcroppings of rock formations. The result is a photographic image remarkably similar to those Moore kept in his studio and used as inspiration for his own two and three piece sculptures, which in turn were sited in landscape (figs. 4, 8). Found objects are also used by the American artist and anthropologist Susan Hiller (b.1940) in investigating notions of place, culture and memory. Hiller writes:

> I have always used a concept of 'truth to material' which accurately or not, was invariably attached to [Moore's] work when I was a student. Certainly I have used this idea against the grain and on the margins of what is defined as the practice of sculpture. But ideas have to begin somewhere, and for me this idea started with Moore . . . I was intrigued to discover only recently that Moore himself did not have any doctrinaire attachment to the idea and that in terms of his work in bronze he seemed to want to free himself from any proscriptive interpretation of it.[18]

Anish Kapoor (b.1954) in his realisations of mysterious interior spaces and the void, and Rachel Whiteread (b.1963) with her casting of interior spaces continue the same sculptural vocabulary of internal/external forms that Moore explored throughout his career. The hollowed square white form of Kapoor's *Untitled* 1997 in white marble, placed outside the Chiesa di San Giusto and Pinacoteca Civica in Volterra, invites comparison with Moore's **Large Square Form with Cut** 1969–71 (LH 599) in Rio Serra marble sited at the Forte di Belvedere in Florence in 1972, now in Prato (figs. 9, 10). Despite Moore's estrangement from the mainstream of the avant-garde, it would be a mistake to conclude that his work is disconnected from the art of today.

Paradoxically, the perceived distancing could in part be due to the very fact that Moore was promoted so heavily by the British Council during the Cold War. This began with a bang at the 1948 Venice Biennale, in which Moore was chosen as the sole artist to represent Britain and came home with the international prize for sculpture. In the 1952 Biennale, Moore's **Double Standing Figure** 1950 (LH 291) (fig. 11) was exhibited at the entrance to the British Pavilion, to introduce the next generation of British sculptors, whose tense angular

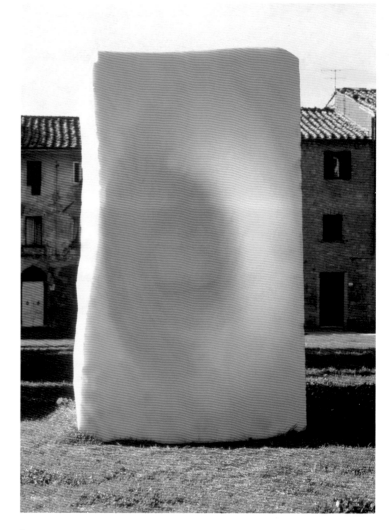

fig. 9
Anish Kapoor, *Untitled* 1997, white marble sited outside the Chiesa di San Giusto and Pinacoteca Civica in Volterra

fig. 10
Large Square Form with Cut 1969–71 (LH 599), Rio Serra marble, exhibited at the Forte di Belvedere, Florence 1972

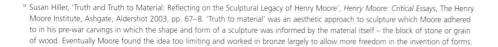

18 Susan Hiller, 'Truth and Truth to Material: Reflecting on the Sculptural Legacy of Henry Moore', *Henry Moore: Critical Essays*, The Henry Moore Institute, Ashgate, Aldershot 2003, pp. 67–8. 'Truth to material' was an aesthetic approach to sculpture which Moore adhered to in his pre-war carvings in which the shape and form of a sculpture was informed by the material itself – the block of stone or grain of wood. Eventually Moore found the idea too limiting and worked in bronze largely to allow more freedom in the invention of forms.

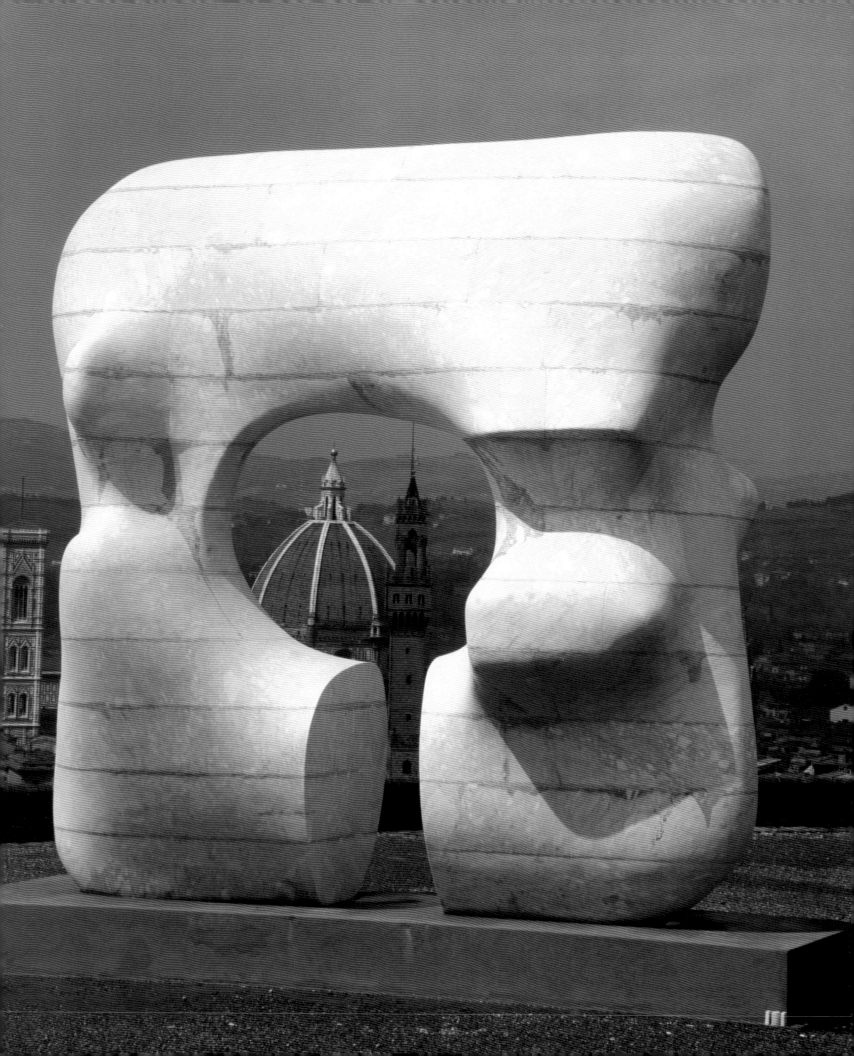

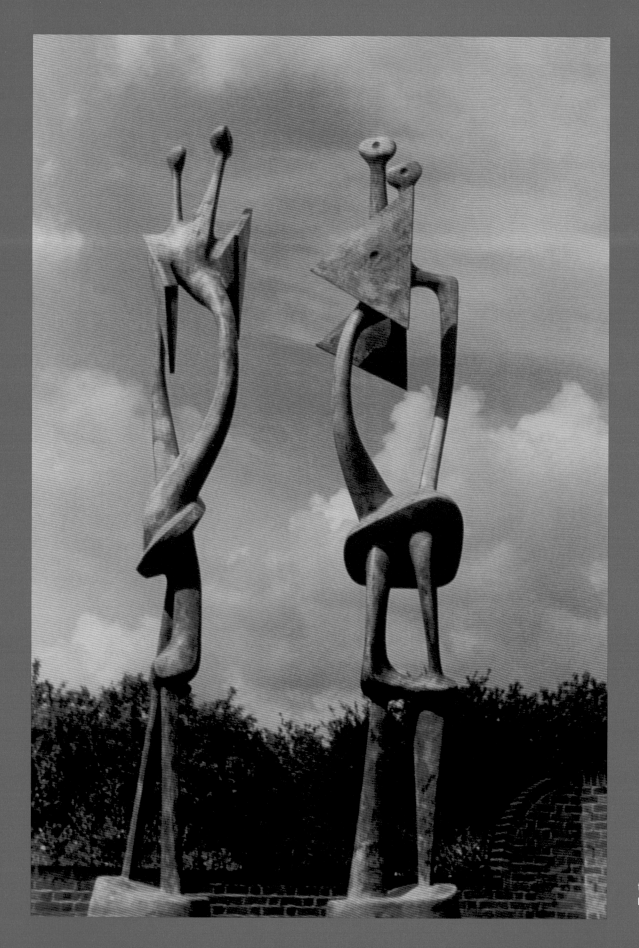

fig. 11
Double Standing Figure
1950 (LH 291)

> "A sculpture must have its own life. Rather than give the impression of a smaller object carved out of a bigger block, it should make the observer feel that what he is seeing contains within itself its own organic energy thrusting outwards – if a work of sculpture has its own life and form, it will be alive and expansive, seeming larger than the stone or wood from which it is carved. It should always give the impression, whether carved or modelled, of having grown organically, created by pressure from within."

'The Sculptor Speaks', *The Listener*, 18 August 1937

forms revealed a post-war angst and were labelled 'the geometry of fear'.[19] Between 1950 and 1960 the British Council organised touring exhibitions of Moore's work with a bewildering eighty-two venues in over twenty different countries.[20] That Moore's sculpture was distinctly modern yet fundamentally humanist provided a stark contrast to the bombastic realism being produced in the Soviet Union.

It could be argued that Moore's acceptance by the establishment provoked a rejection by younger artists who felt the need to be subversive in order to be noticed, culminating with the notoriety of later exhibitions such as the Royal Academy's *Sensation* in 1997. Hiller recalled:

> 'Moore was everywhere during my childhood, a conservative, figurative artist (we thought), a sort of official artist. He was English but his work was ubiquitous in the United States, not just in exhibitions but also in photographs in magazines and books Friends of mine spent many hours looking at blocks of wood trying to decide what figure dwelt inside, waiting to be let out. It was interesting but hopeless. I didn't try. I made a work in cast stone which retained the block-like shape of the shoebox used for casting no one liked it much. I didn't make any more objects after that for years.[21]

Another response has been that of irony, and includes works such as Bruce Nauman's *Seated Storage Capsule for H.M. Made of Metallic Plastic* 1966 (fig. 12) and *Henry Moore Bound to Fail* 1967 both of which satire Moore's interest in the mystery of interior space;

fig. 12
Bruce Nauman's *Seated Storage Capsule for H.M. Made of Metallic Plastic* 1966

[19] Artists included Robert Adams, Kenneth Armitage, Reg Butler, Lynn Chadwick, Geoffrey Clarke, Bernard Meadows, Eduardo Paolozzi and William Turnbull. The name for the group was coined by Herbert Read.

[20] Belgium, France, Holland, Germany, Switzerland, Greece, Mexico, Austria, Sweden, Norway, Denmark, Finland, Yugoslavia, Czechoslovakia, Canada, New Zealand, South Africa, Japan, Portugal and Spain.

[21] Hiller, op.cit.

fig. 13
David Nash, *Serpentine
Vessels* 1989

Bruce McLean's *Pose Work for Plinths 3* 1971 in which he imitates the positions of Moore's reclining figures and Howard Hodgkin's *A Henry Moore at the Bottom of the Garden* 1975–77 in which the garden is completely overgrown. Presumably the artist was too big to ignore and had to be confronted somehow.

That Moore comprehensively reworked the themes in his sculpture (although to him they were endless and inexhaustible) also led to the sense that there was little other artists could contribute within the same sphere. The art historian David Cohen observed:

> . . . the real reason Moore did not have followers of calibre within his own formal and thematic theory is that he developed his personal language so fully. He himself could say anything in his language, whereas anyone else who began to speak it was trapped in mimicry. This factor, more than jealousy or 'anxiety of influence' ensured that sculptors who came after him were virtually obliged to define themselves in opposition to him.[22]

Hence Moore's sculpture assistants who went on to achieve fame in their own right, such as Anthony Caro and Phillip King, did so using working methods rejected by Moore such as assemblage (creating forms through building up or welding rather than carving or reduction) and painted metal.[23] Yet Cohen himself provides compelling juxtapositions of Moore's **Three Piece Reclining Figure: Draped** 1975

(LH 655) with Kapoor's *Mother as a Mountain* 1985 and Tony Cragg's *New Forms* 1991–92, in which the similarities between the artists' investigations of form are striking. David Nash's hollowed out beech *Serpentine Vessels* 1989 recall Moore's dynamic exploits in elmwood where he endeavoured to open out his sculpture as far as possible within the limitations of the material (figs. 13, 14). The two forms in close proximity to each other, heightening the tension between them, also recall Moore's works at Kew in sculptures such as **Large Two Forms** 1966 (LH 556), **Two Piece Reclining Figure: Points** 1969 (LH 606), **Reclining Figure: Arch Leg** 1969–70 (LH 610) and **Two Piece Reclining Figure: Cut** 1979–81 (LH 758). Nash invites further comparison with Moore with the creation of a work in Denmark entitled *Sheep Spaces* 1993, in which two shapes with hollowed forms are situated in the landscape for sheep to lie under and brush up against as they do with Moore's **Sheep Piece** 1971–72 (LH 627) in Perry Green.[24]

It is now just over twenty years since Moore's death in 1986, and it will probably be another generation before his reputation can be looked at clearly with the advantage of perspective. But an exhibition such as this at Kew, where Moore's most powerful and monumental works are sited within landscape – as they were originally envisioned and to which they are so ideally suited – is bound to rekindle that discussion.

[22] David Cohen, 'Who's Afraid of Henry Moore?', *Henry Moore: Sculpting the 20th Century*, Dallas Museum of Art and Yale University Press, New Haven and London 2001, p.266.

[23] Even Moore's bronzes, which are necessarily welded together as part of the casting process, began as models in plaster which were cut back or carved to achieve the desired form.

[24] See Julian Andrews, *The Sculpture of David Nash*, Lund Humphries, London 1996, p.122.

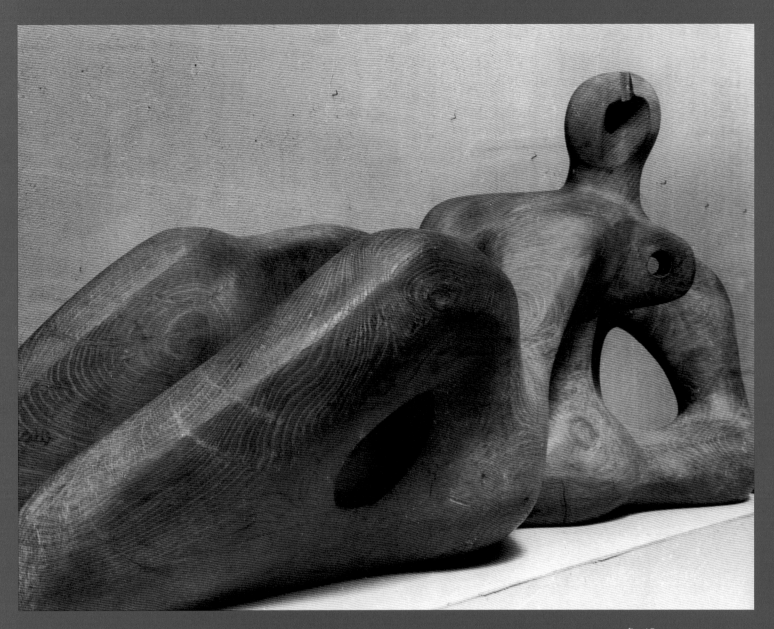

fig. 15
Reclining Figure 1939
(LH 210), elmwood,
The Detroit Institute of Arts

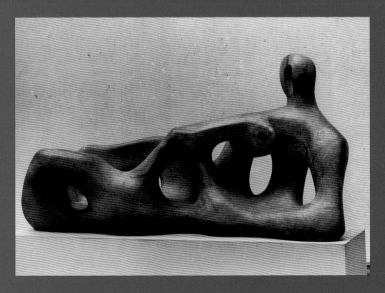

fig. 14
Reclining Figure 1939
(LH 210), elmwood,
The Detroit Institute of Arts

Moore sculptures at Kew

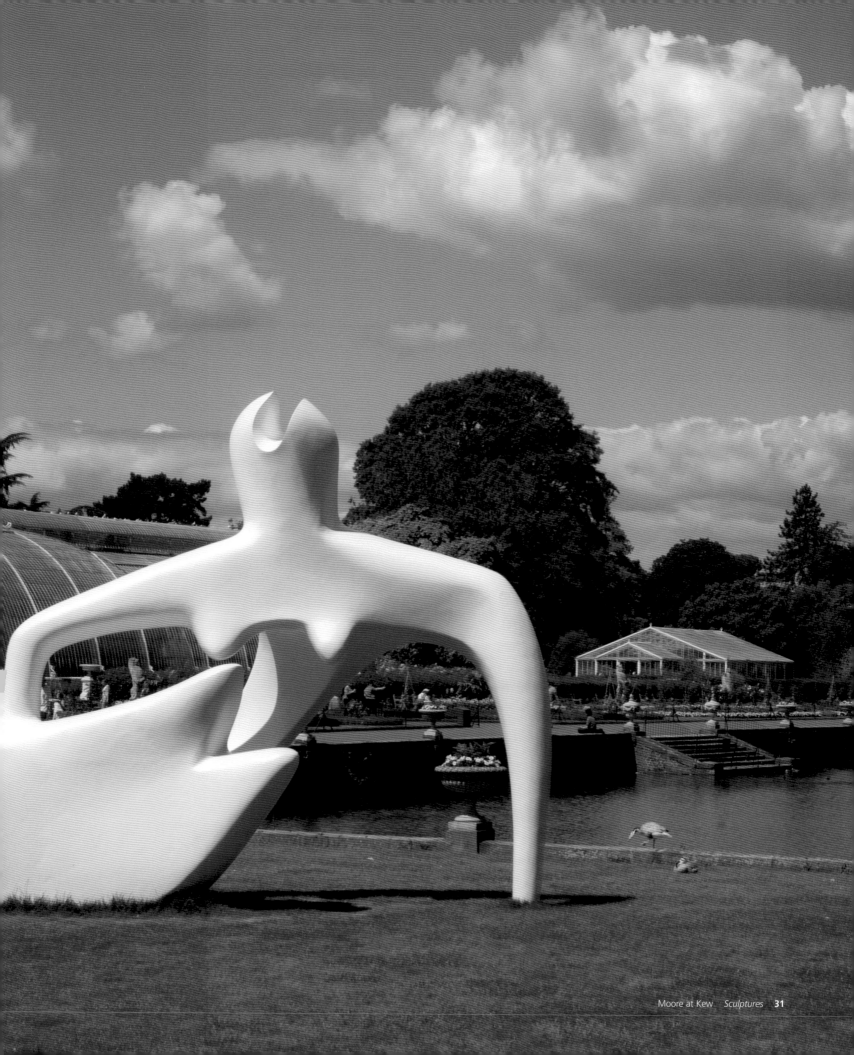

Installation of Large Reclining Figure 1984 (LH 192b) at Kew

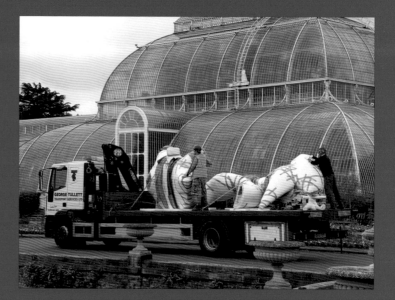

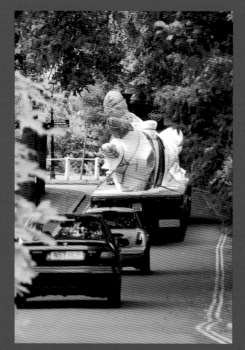

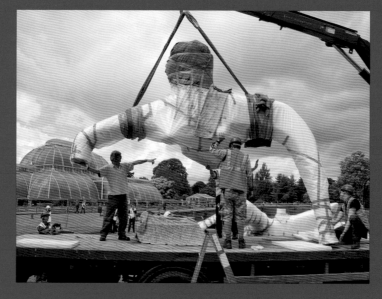

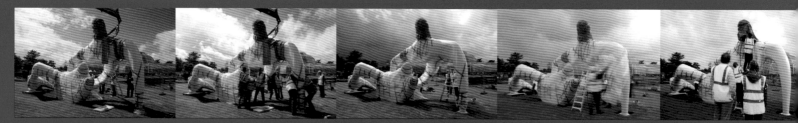

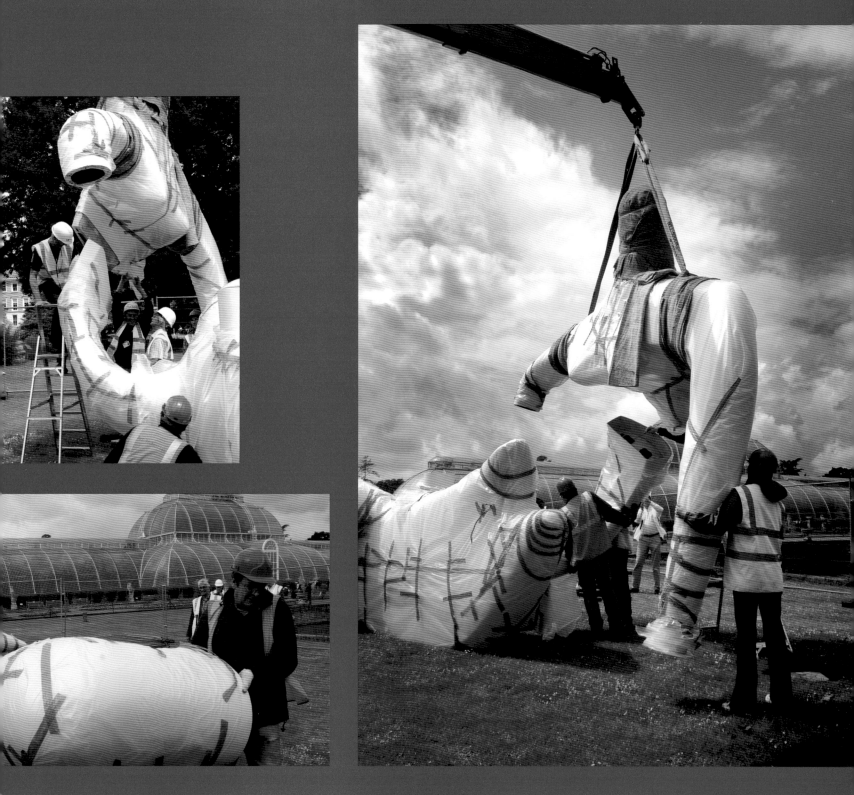
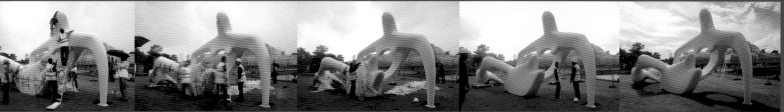

Large Reclining Figure

1984
LH 192b
fibreglass
cast: Edward Lawrence Studios, Midhurst
length 900cm approx.
unsigned
The Henry Moore Foundation: acquired 1987

At the Henry Moore Foundation in Perry Green, Hertfordshire, a bronze cast of **Large Reclining Figure** lies atop a hillock, surveying the estate below. The figure has a striking impact: she appears to be perched, her open slender body leaning on the grass. The shape, though pointed, has a delicate, smooth outline. The simple abstract head appears open, looking skywards, leaving the question of its expression to the viewer's imagination. The frontal aspect of the figure shifts, allowing penetration and views through the work.

As well as this cast in Perry Green, a bronze with a gold patina stands alongside the Overseas Chinese Bank Headquarters in Singapore. The building was designed by the Chinese-born architect I.M. Pei, and standing fifty-two storeys high it was on completion in 1976 the highest building in the Far East. This commission was the fourth and final collaboration between Moore and Pei, who engineered a plaza within the complex specifically for this monumental sculpture.

This work was cast from a polystyrene and plaster enlargement of a small lead reclining figure of 1938. Moore increasingly found that carving in stone and wood had its limitations, and he wanted to preserve the integrity of the material he utilised. Bronze casting permitted him to delve into the form, and the sculptures increasingly opened out, enabling the exploration of internal space within the figure.

Moore did not use fibreglass often, but it had certain advantages due to its lightweight nature. Fibreglass does not have the durability of bronze, or the range of finish and colour, but it enables large-scale works to be produced and transported easily.

This fibreglass cast was previously on loan to the Fitzwilliam Museum, Cambridge. For the duration of this exhibition it has taken up residence by the lake adjacent to Kew's distinctive Palm House, a grade I listed Victorian iron-framed glasshouse.

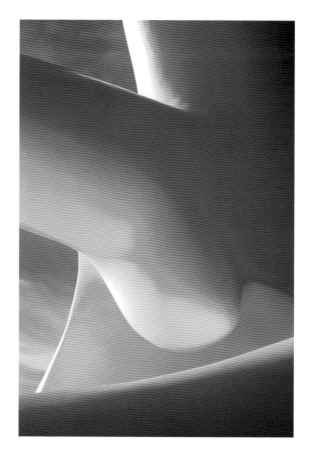

Detail of **Large Reclining Figure**

Large Reclining Figure
at the Royal Botanic
Gardens, Kew

Large Reclining Figure
bronze at I.M. Pei's Overseas
Chinese Bank, Singapore

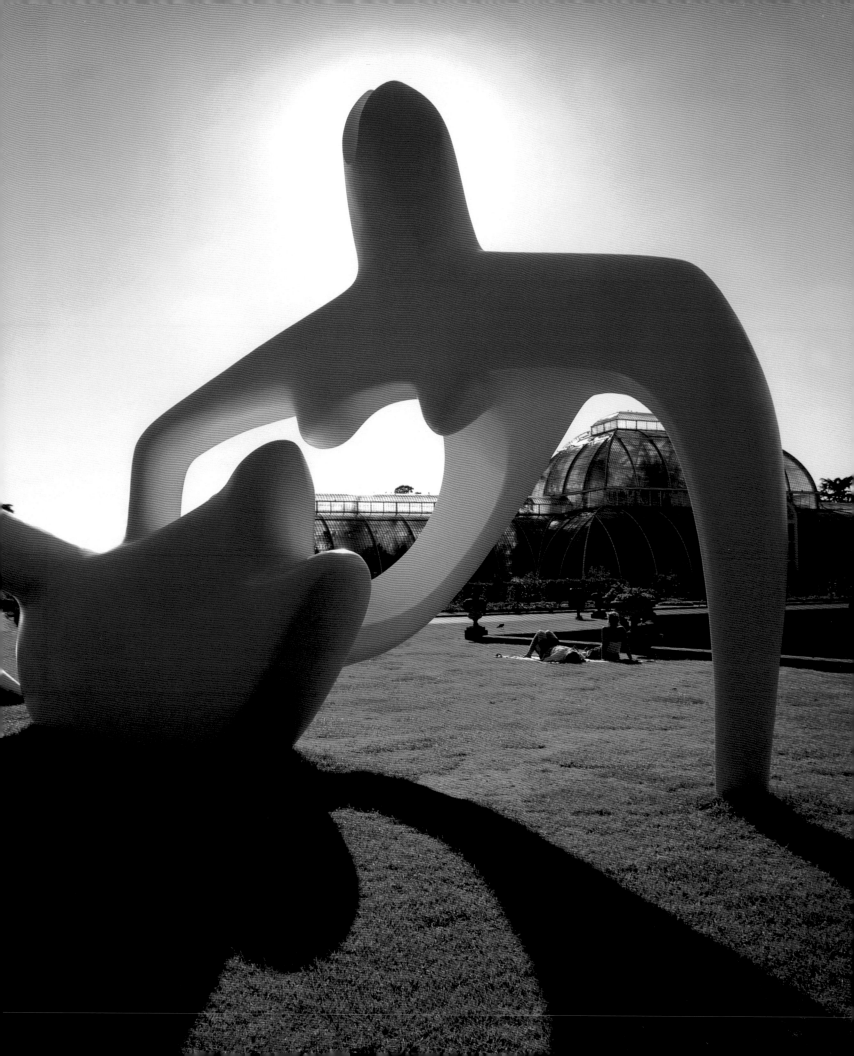

Large Upright Internal/External Form

1981–82
LH 297a
bronze edition of 1 + 1
cast: Morris Singer, Basingstoke 1982
height 673cm
unsigned, [0/1]
The Henry Moore Foundation: acquired 1986

"Now armour is an outside shell like the shell of a snail which is there to protect the more vulnerable forms inside, as it is in human armour which is hard and put on to protect the soft body. This has led sometimes to the idea of the Mother and Child where the outer form, the mother, is protecting the inner form, the child, like a mother does protect her child."

Henry Moore in conversation with David Mitchinson; 1980

The internal/external form is one of the three main themes that reappear throughout Moore's work. Here the smooth outer shell stands sentry-like, bold and tough, guarding within a fragile willowy being. The slender inner body is enveloped by the cocoon-like exterior, and can only be glimpsed in fragments.

This work, like many others in Moore's oeuvre, began life as a maquette, standing just over 21 centimetres high.

The image below shows a plaster version of LH 297 1953–54 – the elmwood carving from which this piece was derived – the plaster cut into sections in preparation for the enlargement process. Enlarging a work to full size was executed manually. A grid system enabled Moore's assistants to calculate exactly the size of each part of the smaller sculpture, and using a hot wire they cut a scaled-up version of each section into the 45 centimetre deep blocks of polystyrene. Excess polystyrene was removed using saws and wire brushes. These sections would then be shaped until each segment married up to its adjacent piece. Upper parts of the form were often altered by the artist to compensate for the new perspective offered by the increased height of the sculpture. These blocks were then sent to a bronze foundry, in this case Morris Singer, cast section by section and then welded together.

This sculpture is usually on display at the Henry Moore Foundation in Perry Green; the only other cast is in the First National Plaza, Chicago.

Laura Robinson, Sculpture Conservator at the Henry Moore Foundation preparing **Large Upright Internal/External Form** for exhibition at the Royal Botanic Gardens, Kew

Plaster and polystyrene sections for enlargement of **Large Upright Internal/External Form**, Perry Green

Large Upright Internal/External Form at the Royal Botanic Gardens, Kew

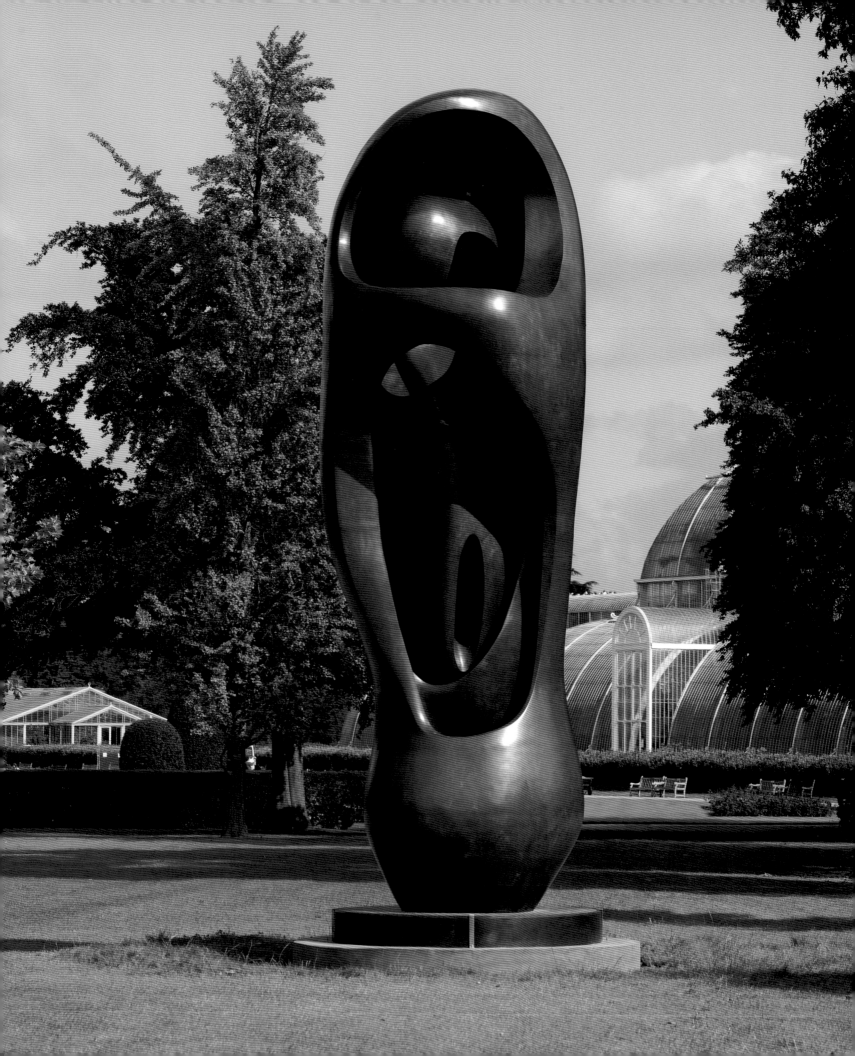

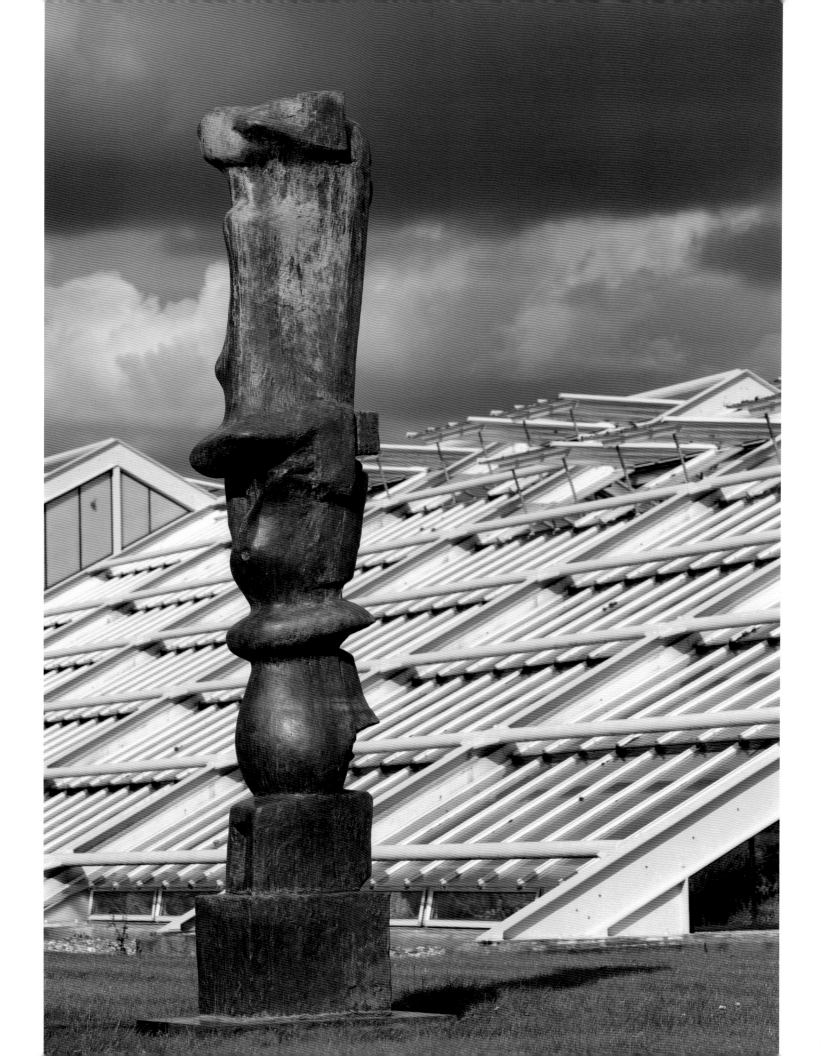

Upright Motive No.2

1955
LH 379
bronze edition of 5 + 1
cast: H.H. Martyn, Cheltenham
height 320cm
unsigned, unnumbered
Harlow Art Trust

Upright Motive No.2
at the Royal Botanic
Gardens, Kew

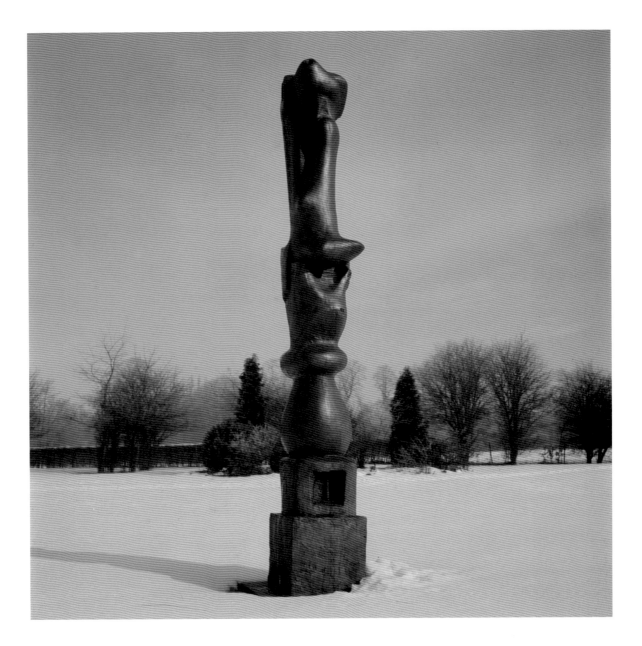

Upright Motive No.2 in
the snow at Perry Green

Upright Motive No.5

1955–56
LH 383
bronze edition of 7 + 1
cast: The Art Bronze Foundry, London
height 213.5cm
signature: stamped Moore, [0/7]
The Henry Moore Foundation: gift of the artist 1977

Detail of **Upright Motive No.5** after a frost in Perry Green

Upright Motive No.5 at the Royal Botanic Gardens, Kew

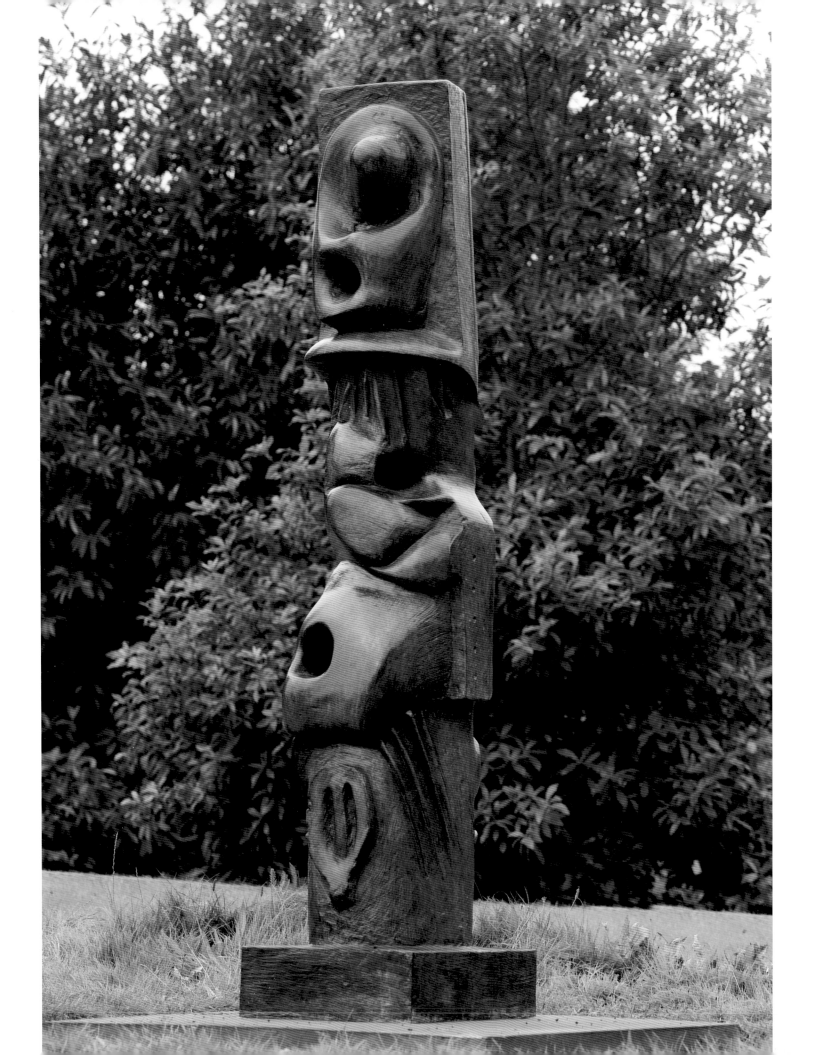

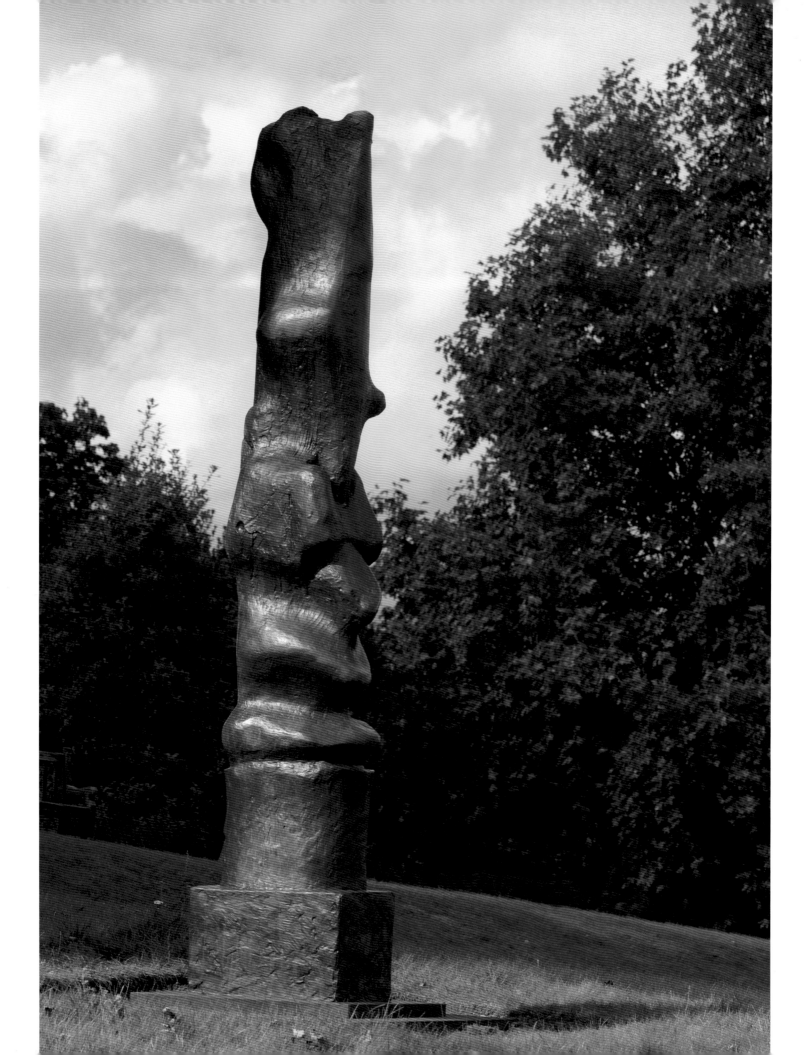

Upright Motive No.7

1955–56
LH 386
bronze edition of 5 + 1
cast: H.H. Martyn, Cheltenham
height 320cm
unsigned, [0/5]
The Henry Moore Foundation: gift of the artist 1977

Detail of **Upright Motive No.7**

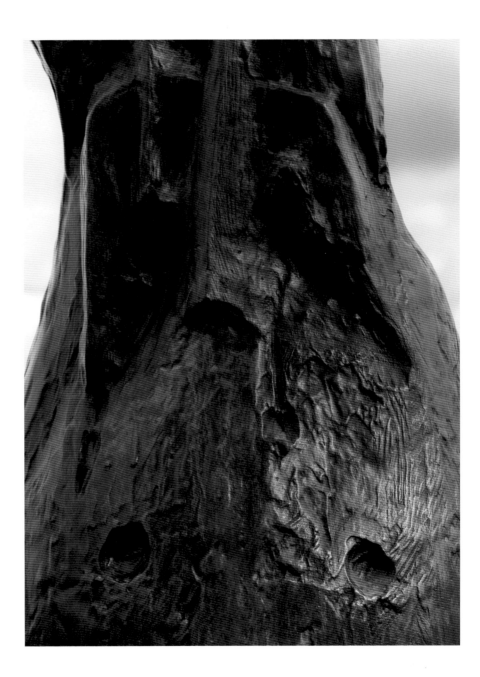

Upright Motive No.7
at the Royal Botanic
Gardens, Kew

Upright Motive No.8

1955–56
LH 388
bronze edition of 7 + 1
cast: Corinthian, London
height 198cm
unsigned, [6/7]
The Henry Moore Foundation: gift of the artist 1979

"Sculpture is like a journey. You have a different view as you return. The three-dimensional world is full of surprises in a way that a two-dimensional world could never be."

Carlton Lake, 'Henry Moore's World', *Atlantic Monthly*, vol.209, no.1, January 1962

The idea of a series of upright motives began while Moore was working with Michael Rosenauer on a design for the English Electric Company Headquarters in London in 1954. Moore produced six upright motive maquettes and two maquettes for corner sculptures, as integral parts of Rosenauer's project. Although the design didn't win the commission, these maquettes became the impetus for the upright motives series.

The theme resurfaced again in the same year when Moore was commissioned to produce a sculpture for a square in the new Olivetti building in Milan. He felt that the space required a vertical work to offset the primarily horizontal design of the building. He began work on an upright figure, and several maquettes were made. The project was never realised, as Moore discovered that the area around the work would be used as a car park.

Moore worked with architects throughout his career: Rosenauer, Charles Holden, Gordon Bunshaft and I.M. Pei amongst others. Moore considered, however, that in general his works' full potential was best realised within a landscape, and in the upright motives he combines organic and industrial motifs to integrate the sculptures within an architectural setting.

These motives, four of which are included in the exhibition at Kew, bring to mind native American totem poles – an association acknowledged by Moore himself and endorsed by many scholars. Others have made links with the Crucifixion, particularly in the case of **Upright Motives No.1** and **8**. But speaking of **Upright Motive No.8** Moore later referred to a more primitive influence, that of a Jamaican wood carving of a bird man, seen by him in the British Museum. The sentry-like forms are confident and solid; their truncated forms have nooks and crannies, deep grooves and intriguing orifices. The motives seem to be life-size – though in reality they are twice as big – and appear ambiguously figurative.

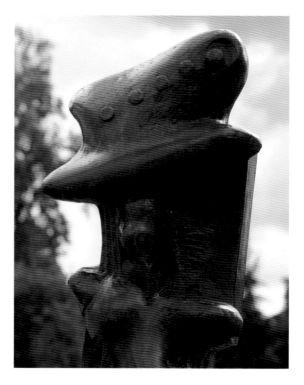

Detail of **Upright Motive No.8**

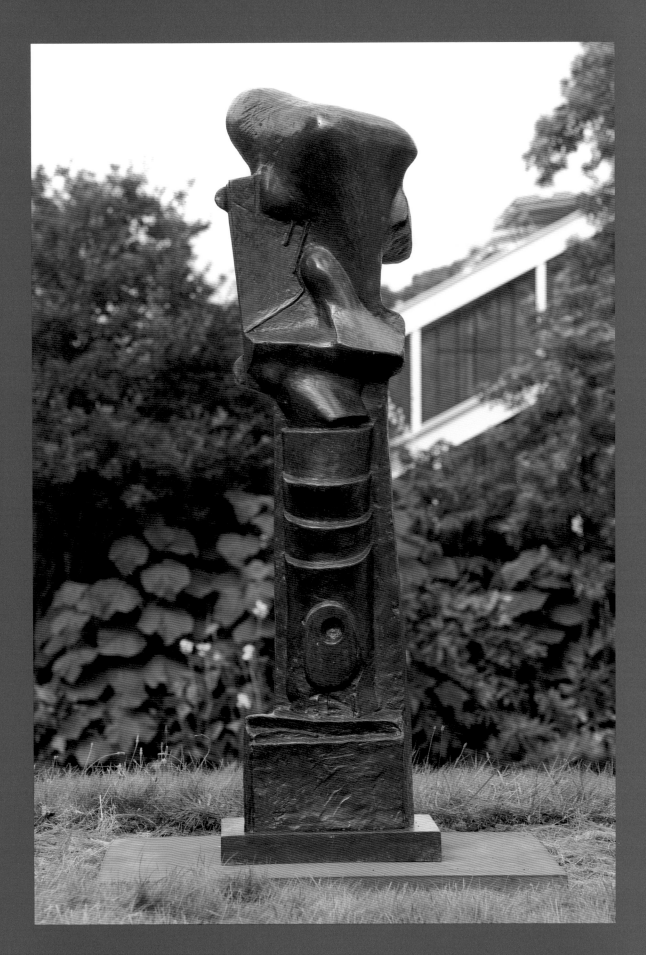

Upright Motive No.8
at the Royal Botanic
Gardens, Kew

Draped Reclining Woman

1957–58
LH 431
bronze edition of 6 + 1
cast: Hermann Noack, Berlin
length 208.5
signature: unsigned, unnumbered
Tate: presented by Gustav and Elly Kahnweiler 1974 and accessioned 1994

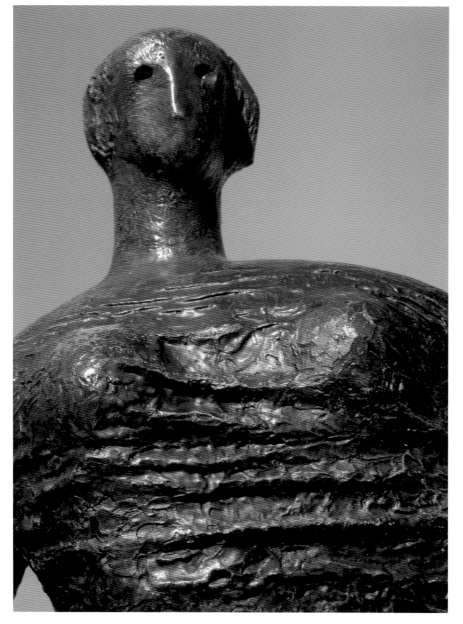

Detail of **Draped Reclining Woman**

Draped Reclining Woman at the Royal Botanic Gardens, Kew

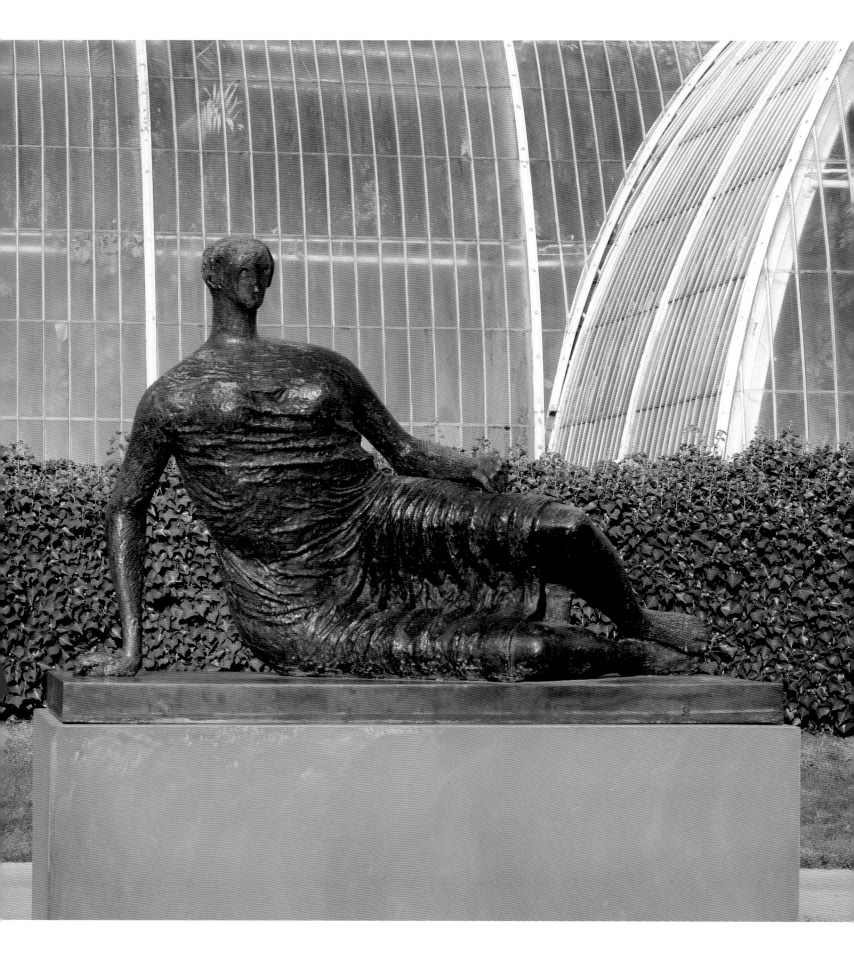

Seated Woman

1958–59
LH 440
bronze edition of 6 + 1
cast: Hermann Noack, Berlin 1975
height 211cm
signature: stamped Moore, 0/6
The Henry Moore Foundation: acquired 1987

Detail of **Seated Woman**

Seated Woman at the
Royal Botanic Gardens, Kew

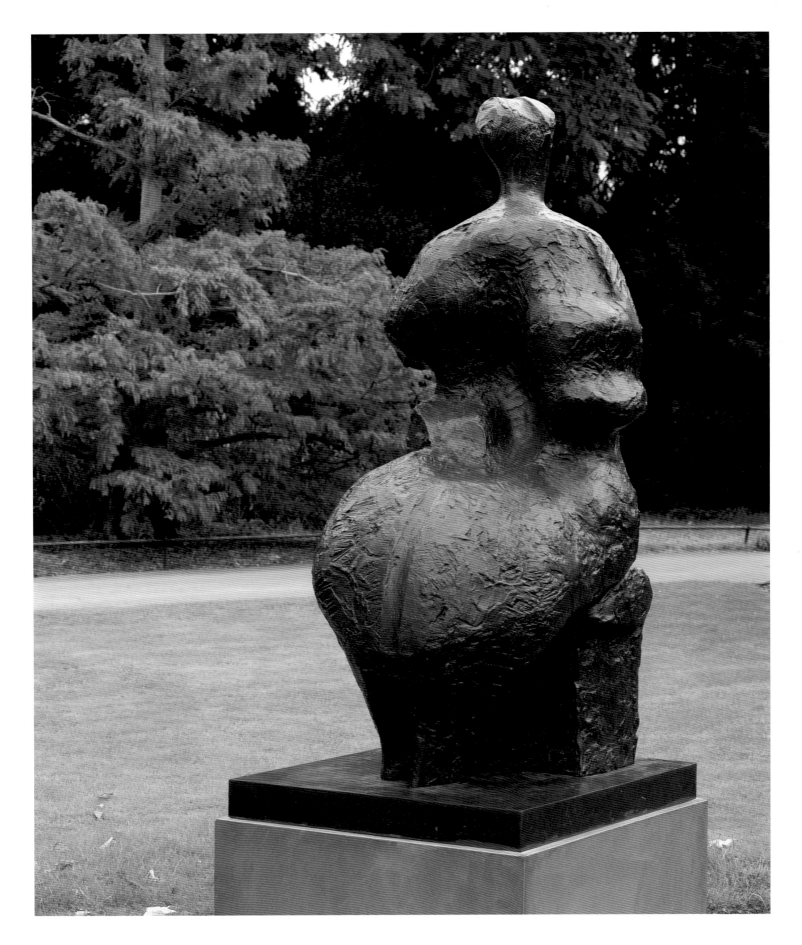

Large Standing Figure: Knife Edge

1976
LH 482a
bronze edition of 6 + 2
cast: Hermann Noack, Berlin
height 358cm
signature: stamped Moore, 0/6
The Henry Moore Foundation: acquired 1987

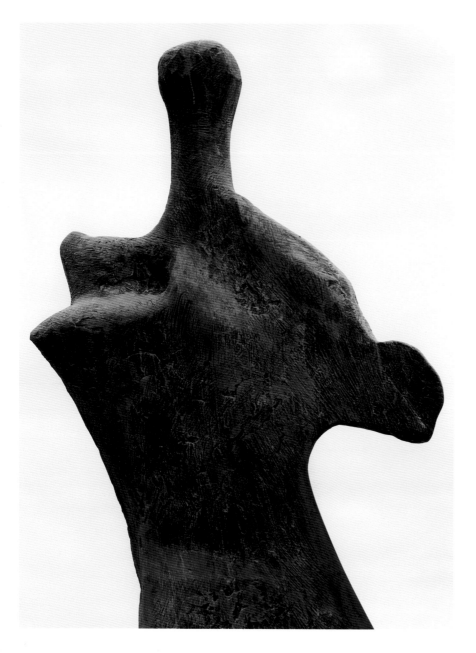

Detail of **Large Standing Figure: Knife Edge**

Large Standing Figure: Knife Edge at the Royal Botanic Gardens, Kew

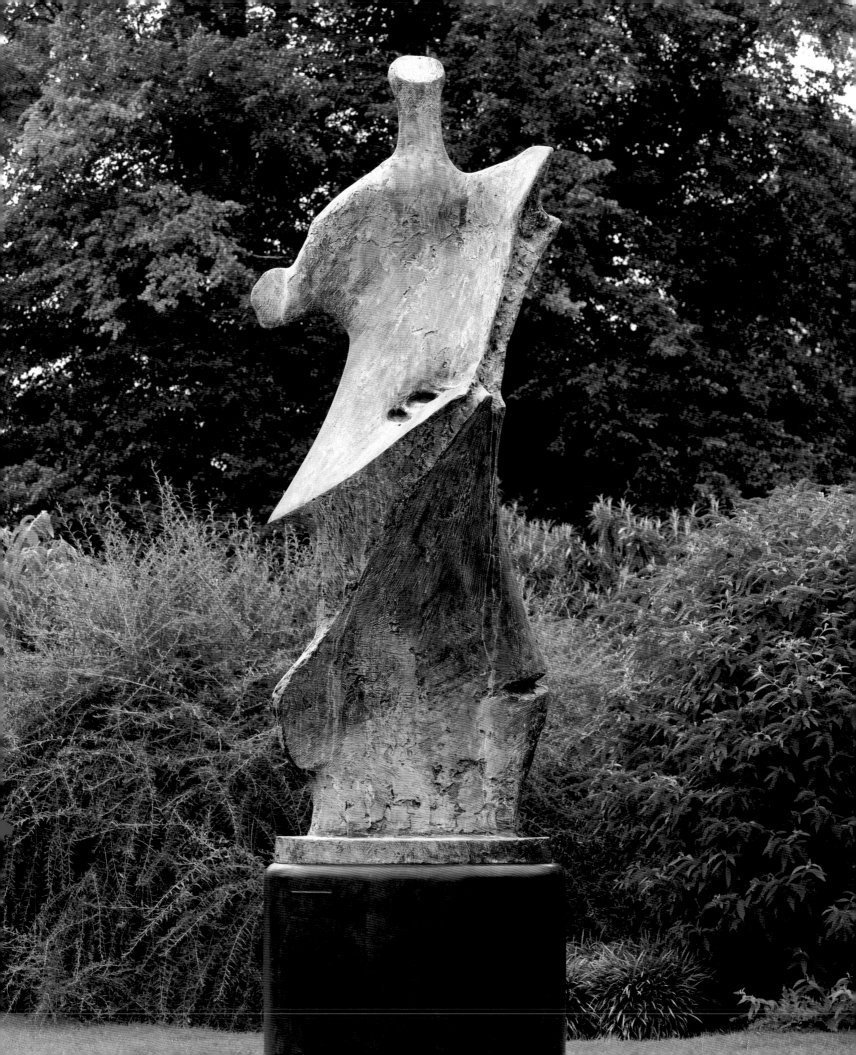

The Wall: Background for Sculpture

1962
LH 483
bronze edition of 1 + 1
cast: The Art Bronze Foundry, London
length 257cm
unsigned, [0/1]
The Henry Moore Foundation: gift of the artist 1977

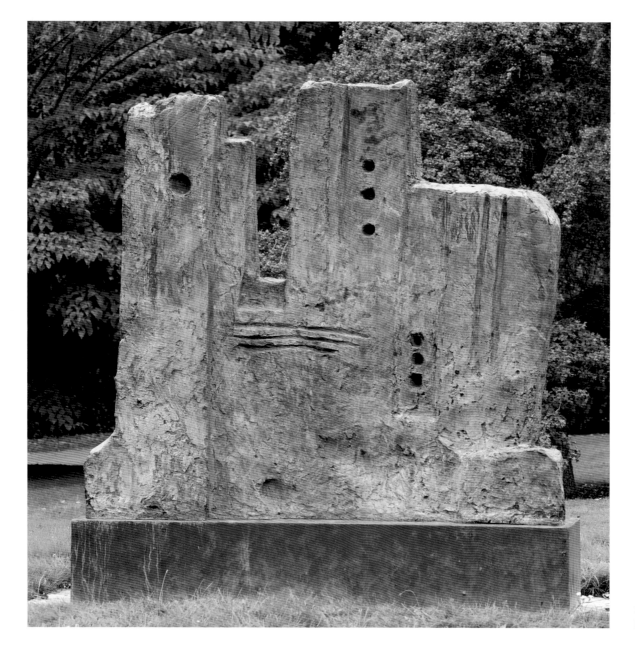

The Wall: Background for Sculpture at the Royal Botanic Gardens, Kew

Detail of **The Wall: Background for Sculpture**

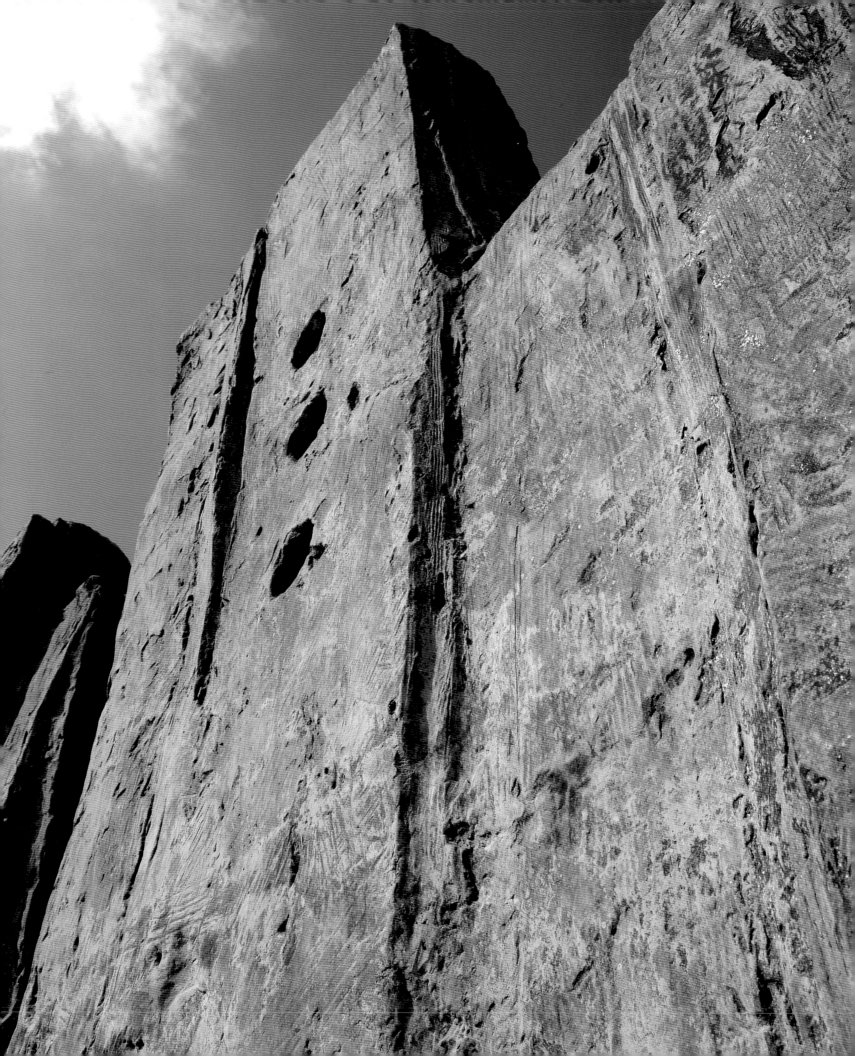

Locking Piece

1963–64
LH 515
bronze edition of 3 + 1
cast: Hermann Noack, Berlin
height 290cm
unsigned, [0/3]
The Henry Moore Foundation: acquired 1987

Standing in front of these two intertwined bronze forms, one wants to solve the puzzle. Do the pieces come apart? The echo of the pebbles that stimulated the artist is still clear. The two forms curve around each other, and appear inextricably knotted together. Intrigued by the shapes, exploring the different points of contact, as observers we recognise the grinding weight of the upper form pressing down on its lower half.

Moore was fascinated by found objects such as flint stones, driftwood and animal bones. The sculptures on display in the Royal Botanic Gardens at Kew are distinguished by their monumentality, but their origin was often more intimate. So too was Moore's design method. When he returned to sculpture after the war Moore began making small models with a view to developing a form worthy of enlargement. He found that this technique enabled him to see the work from all angles, saving him from having to execute countless drawings to achieve the same object. From 1929 Moore lived and worked in Hampstead, London, with his wife, Irina, but when their home suffered irreparable bomb damage during the Blitz in 1940 the couple decided to move to the relative tranquillity of the Hertfordshire countryside. An unforeseen advantage of this relocation was the discovery of buried animal bones in the surrounding grounds of their new home.

Over the years Moore built up an enormous collection of these natural forms, which formed the basis of many small maquettes. A selection of the most successful was enlarged – sometimes on a grand scale, as we see in the works exhibited here.

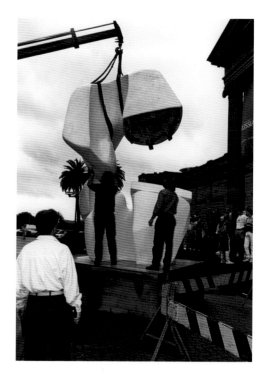

Locking Piece fibreglass, being assembled for *Henry Moore the Human Dimension*, St Petersburgh 1991

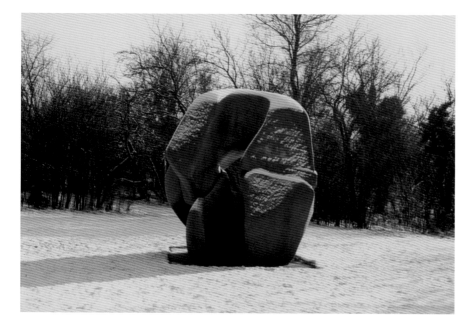

Locking Piece in the snow, Perry Green

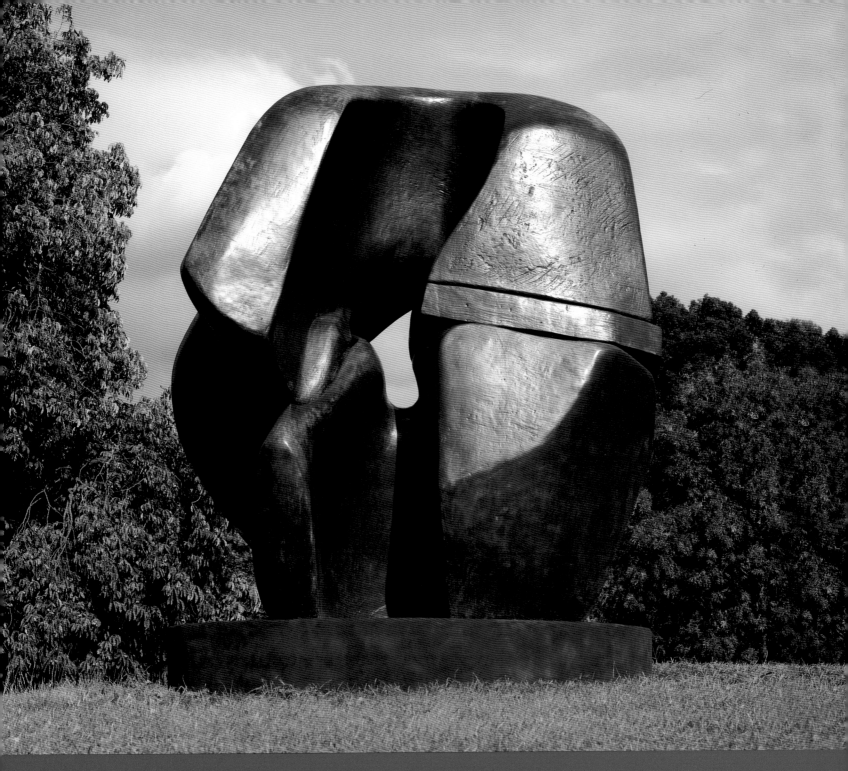

Locking Piece at the Royal
Botanic Gardens, Kew

"Anyhow, I was playing with a couple of pebbles and I found that . . . they got locked together and I couldn't get them undone and I wondered how they got in that position and it was like a clenched fist. . . . this gave me the idea of making two forms which would do that and later I called it *Locking Piece* because they lock together."

In conversation with Alan Wilkinson, c.1980

Knife Edge Two Piece

1962–65
LH 516
bronze edition of 3 + 1
cast: Hermann Noack, Berlin
length 366cm
signature: stamped Moore, 0/3
The Henry Moore Foundation: gift of the artist 1977

Moore grew up in Castleford, an industrial town in the north of England. Within only a few miles of his home were the hills and dales of Yorkshire, an area renowned for its majestic scenery. On family expeditions he would explore the rugged countryside strewn with rocks and boulders – monumental organic forms peppering the landscape.

There are traces of these childhood experiences within Moore's full-scale sculptures. This piece outlines the harmony of the solid mass of the bronze and its negative space. Both are crucial to the enormity and weight of the work; the divide gives us a peek through it, framing a slice of its surroundings, inviting us to explore both the piece itself and the effect it has on its environs. The two forms are similar in shape, but indicate the organic asymmetry characteristic of Moore's work. This abstract sculpture may not have the figurative aspects often found in his compositions, but the relationship between two forms is still present, showing how the natural form and monumentality flourish in synchrony.

This work embodies solidity: the organic, wedge-like forms slice through the sky. There is tension between the two segments as they stretch upwards side by side. The space separating them is a ravine, cutting a swathe through to the view behind.

Throughout his career Moore relied on a handful of foundries to cast his work. The large-scale bronzes were produced at Morris Singer in Basingstoke or, as in the case of this work, Hermann Noack in Berlin. Other foundries he used included three London companies, Galizia, Fiorini and the Art Bronze Foundry, and Susse Fondeur in Paris.

This work is familiar to our nation, as a cast stands in Parliament Square, in London, and often forms the backdrop for televised interviews. A larger but reversed version, **Mirror Knife Edge** 1977 (LH 714), was made for the entrance to the east wing of the National Gallery of Art, Washington DC, designed by I.M. Pei.

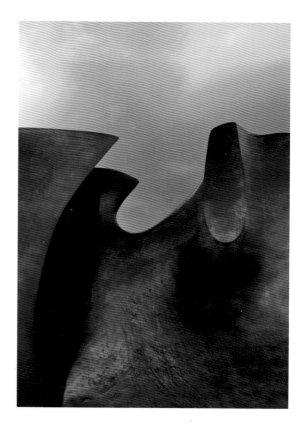

Detail of **Knife Edge Two Piece**

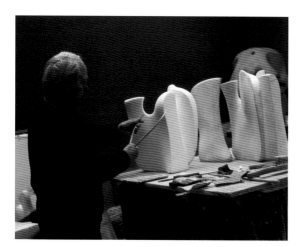

Henry Moore with pair of callipers and polystyrene and plaster sections for enlargement and casting of **Working Model for Knife Edge Two Piece** (LH 504), Perry Green, 1962

Knife Edge Two Piece
at the Royal Botanic
Gardens, Kew

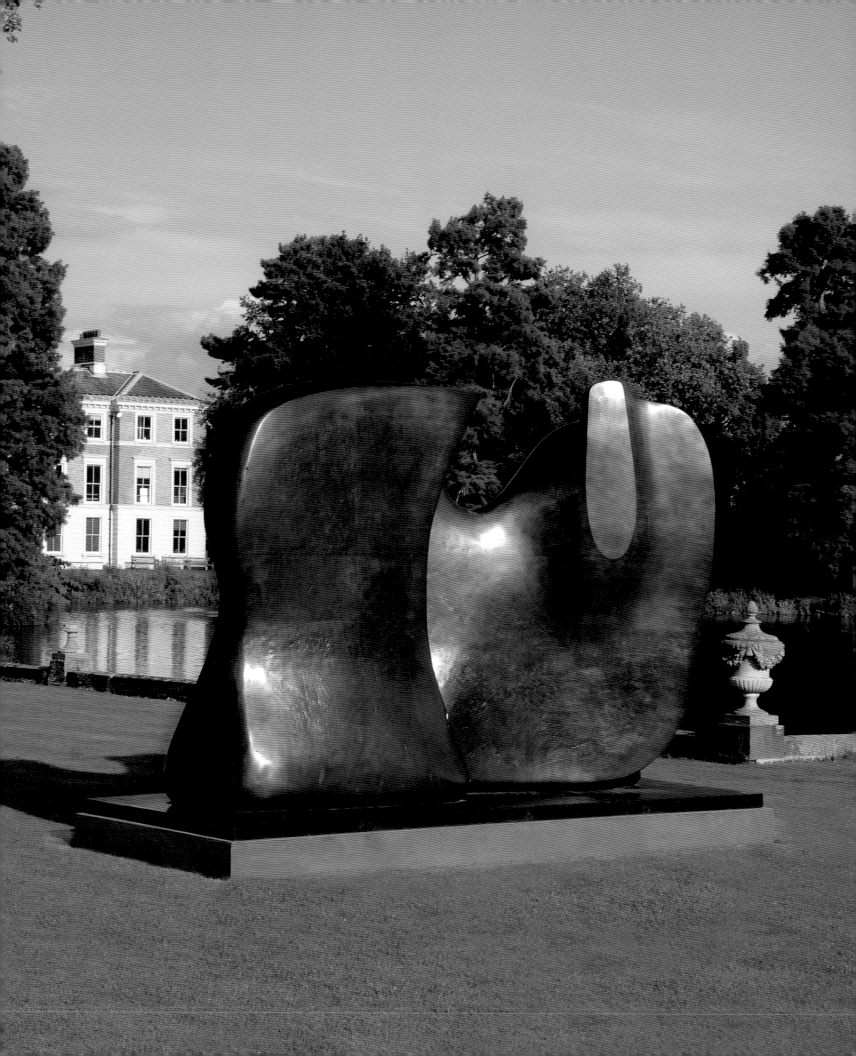

Large Two Forms

1966
LH 556
bronze edition of 4 + 1
cast: Hermann Noack, Berlin
length 610cm
signature: stamped Moore, 0/4
The Henry Moore Foundation: acquired 1992

Detail of **Large Two Forms**

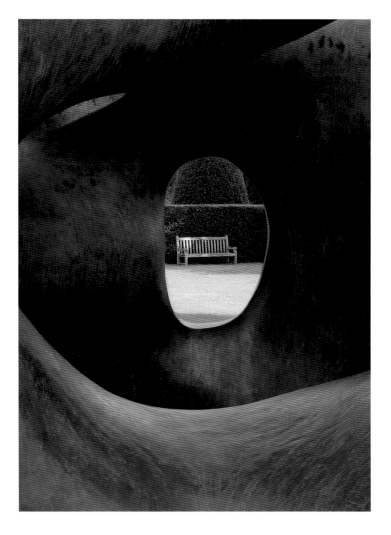

Large Two Forms at the
Royal Botanic Gardens, Kew

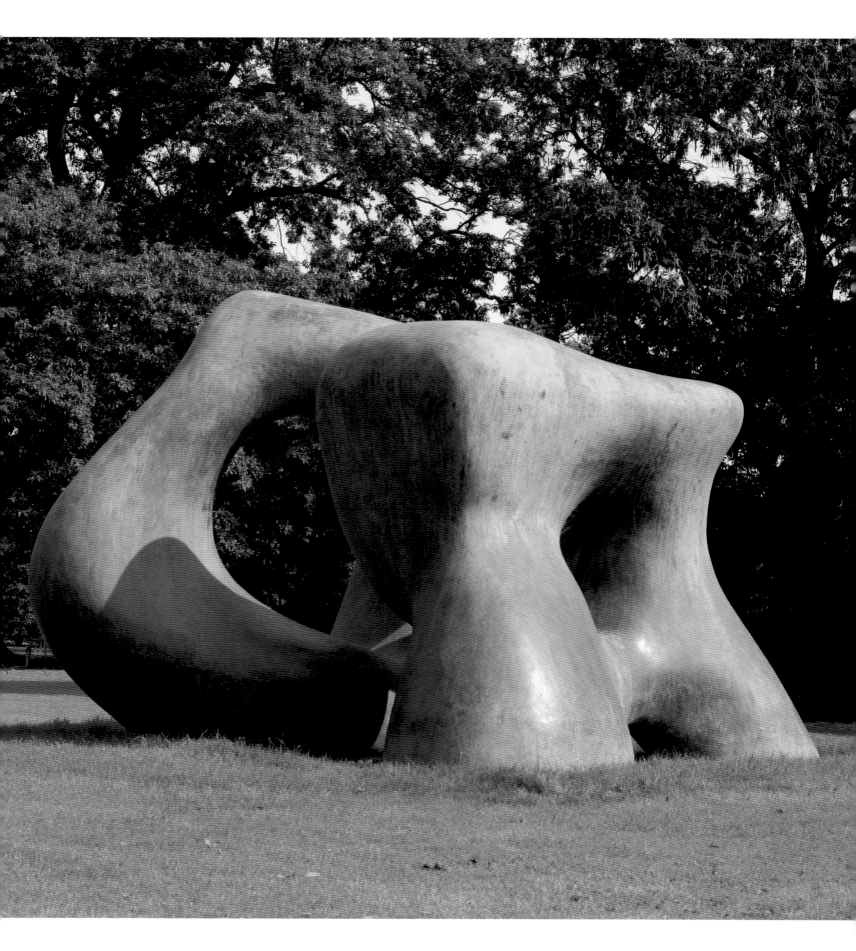

Double Oval

1966
LH 560
bronze edition of 2 + 1
cast: Hermann Noack, Berlin
length 550cm
signature: stamped Moore, 0/2
The Henry Moore Foundation: acquired 1992

Double Oval has enormous impact, viewed both at close quarters and from a distance. It is a work that must be explored thoroughly in the round. Looking at it we sense that the visible form is the tip of the iceberg. Does the ground below conceal a continuation of the forms; is the part emerging from the ground merely a hint of an immense subterranean bronze? In reality, the hidden component of the sculpture is a crucial part of the work. The two pieces have a steel frame below ground, supporting the mass of bronze. There is a specific footprint for positioning this work, and when moved it has to be carefully dug out of the ground and lifted with a heavy-duty crane. Each new site must be prepared carefully, and footings are made to ensure that the work sits on a solid foundation.

 Double Oval demonstrates one of the central themes of Moore's work: the simplicity of organic mass. At first sight the two pieces appear the same, but on closer inspection they differ in shape. As we move around the work, the importance of the holes becomes apparent; looking through them we see not only the landscape but a portion of the other form. The surface is smooth in some parts and textured in others, which gives a sensation of depth and shade. As with many of the sculptures on display at Kew, the space between the two forms is critical to the monumentality of the piece.

 Only two other casts were made; these are located at Pepsi Co. New York and I.M. Pei's Hong Kong Land Company. The positioning of the two forms in relation to each other is individual to each site, thus altering slightly the impression they create.

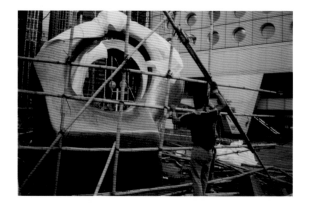

Double Oval undergoing conservation in Hong Kong

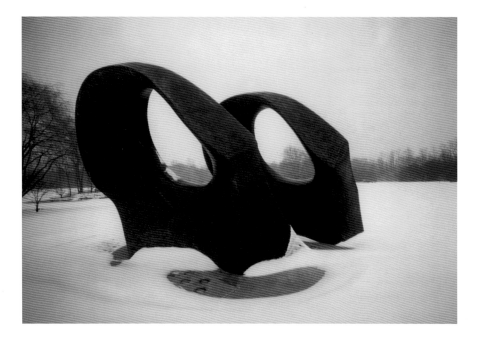

Double Oval, Donald M Kendall Sculpture Gardens, Pepsico World Headquarters, Purchase, New York

Double Oval at the Royal Botanic Gardens, Kew

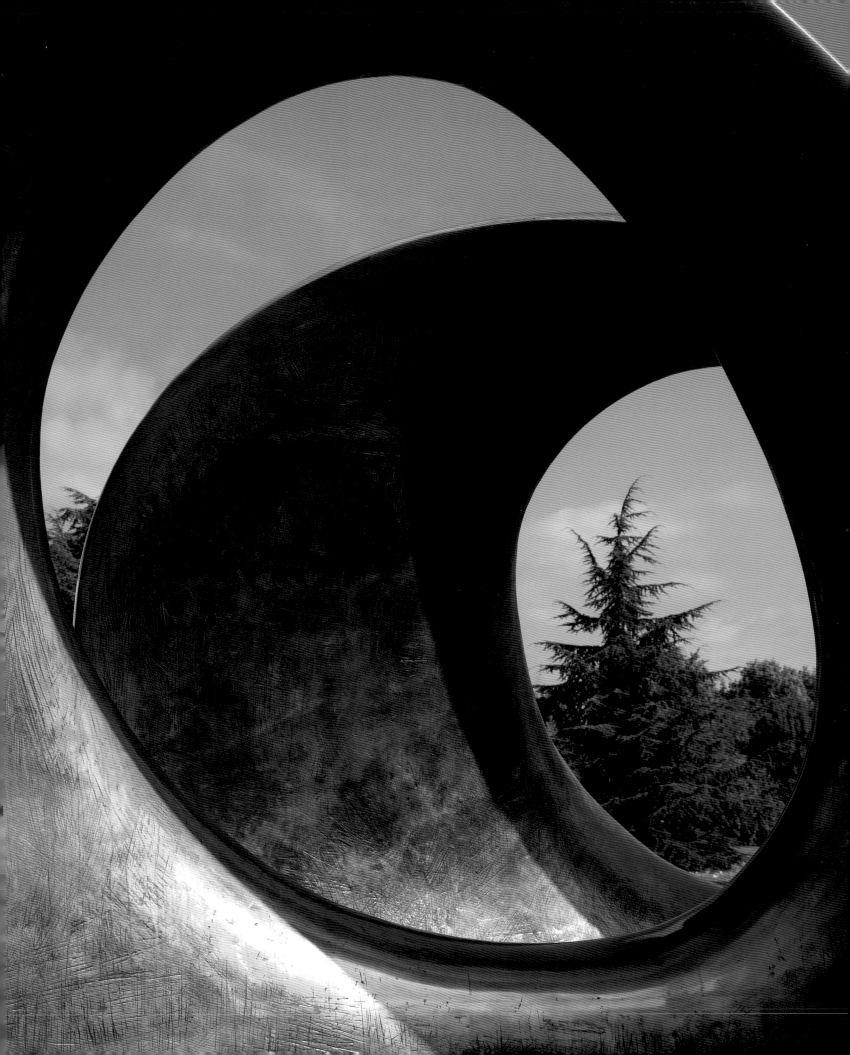

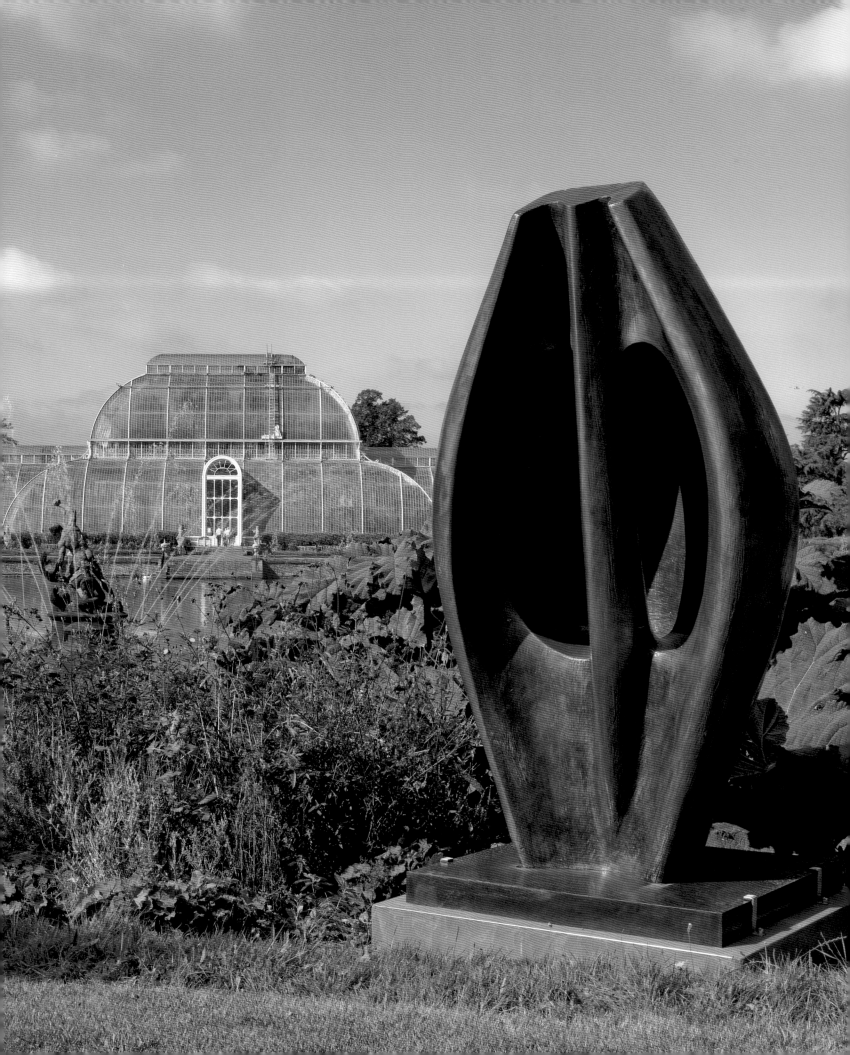

Large Totem Head

1968
LH 577
bronze edition of 8 + 1
cast: Hermann Noack, Berlin
height 244cm
signature: stamped Moore, 0/8
The Henry Moore Foundation: acquired 1987

Detail of **Large Totem Head**

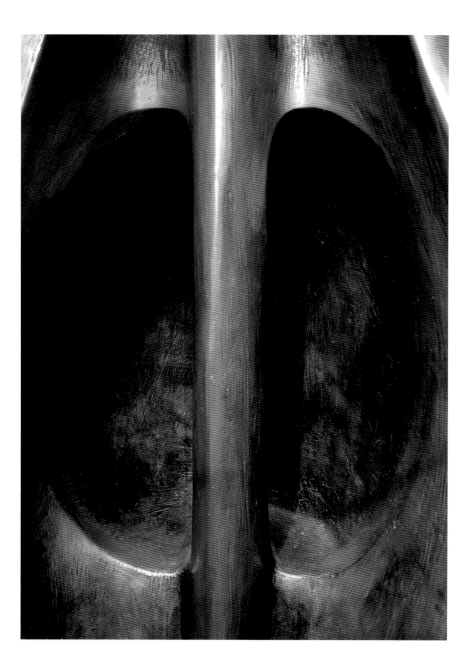

Large Totem Head at the
Royal Botanic Gardens, Kew

Large Spindle Piece

1974
LH 593
bronze edition of 6 + 1
cast: Hermann Noack, Berlin
height 335cm
signature: stamped Moore, 0/6
The Henry Moore Foundation: acquired 1986

Details of **Large
Spindle Piece**

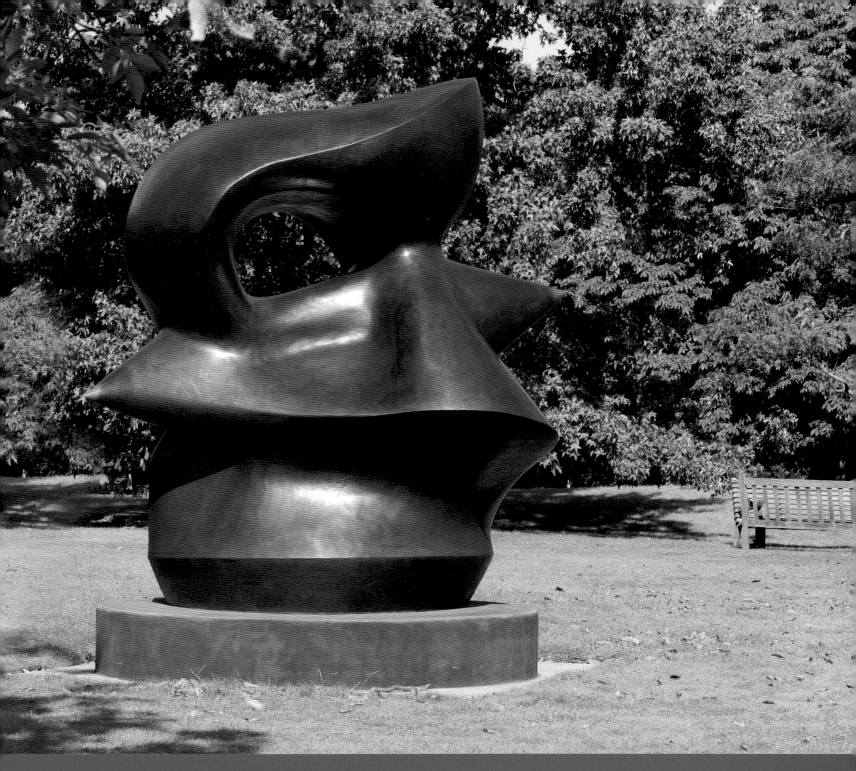

Large Spindle Piece at the
Royal Botanic Gardens, Kew

Oval with Points

1968–70
LH 596
bronze edition of 6 + 1
cast: Morris Singer, Basingstoke
height 332cm
signature: stamped Moore, 0/6
The Henry Moore Foundation: gift of the artist 1977

Detail of **Oval with Points**

Oval with Points at the
Royal Botanic Gardens, Kew

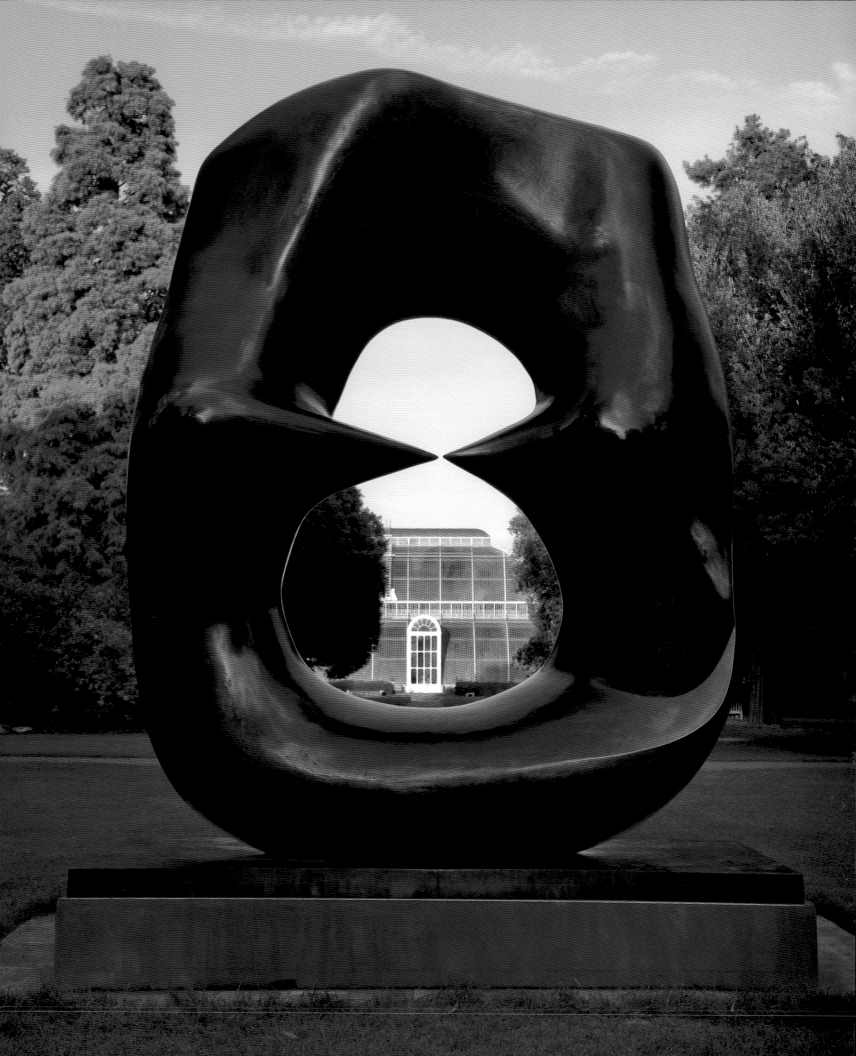

Two Piece Reclining Figure: Points

1969
LH 606
bronze edition of 7 + 1
cast: Hermann Noack, Berlin
length 365cm
signature: stamped Moore, 0/7
The Henry Moore Foundation: gift of the artist 1977

Detail of **Two Piece
Reclining Figure: Points**

**Two Piece Reclining
Figure: Points** at the Royal
Botanic Gardens, Kew

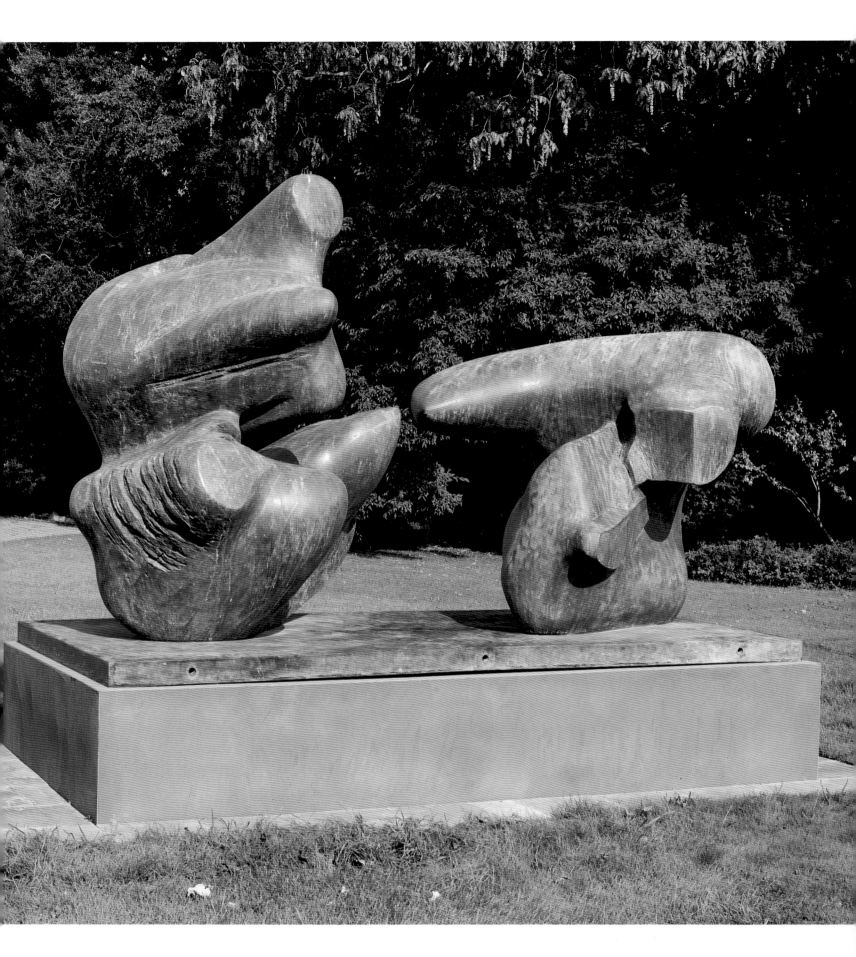

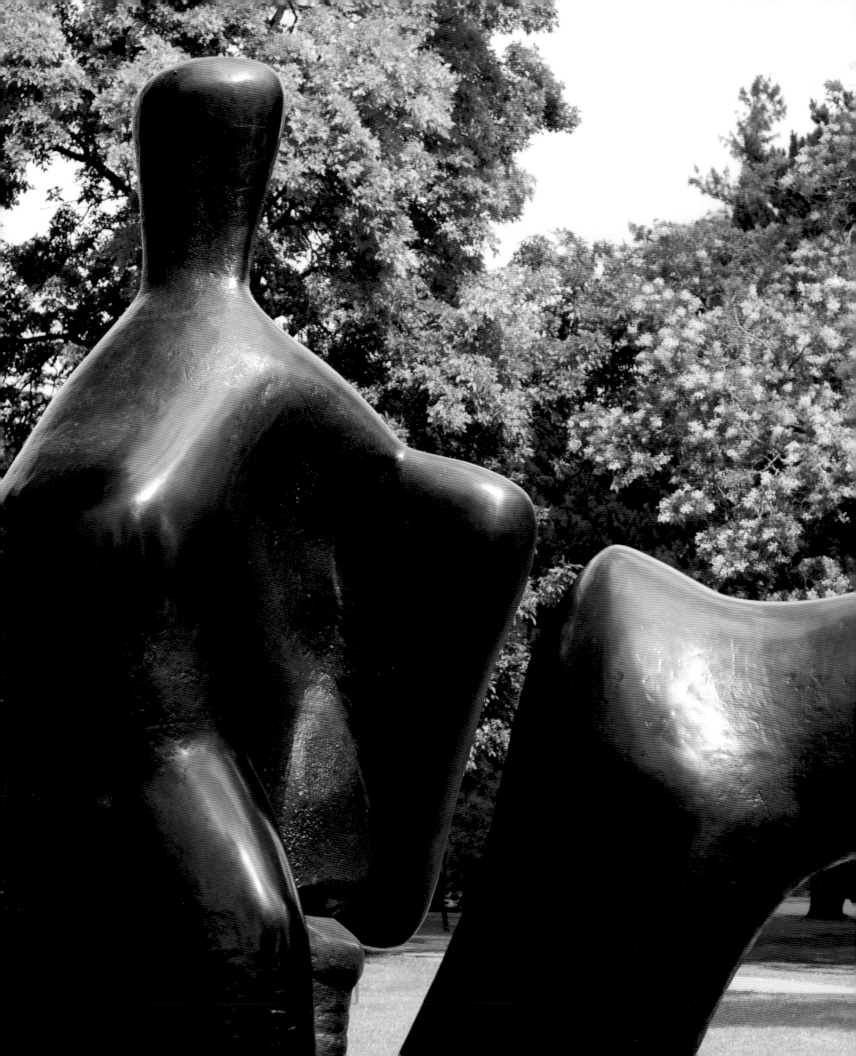

Reclining Figure: Arch Leg

1969–70
LH 610
bronze edition of 6 + 1
cast: Hermann Noack, Berlin
length 442cm approx.
signature: stamped Moore, 0/6
The Henry Moore Foundation: acquired 1987

Detail of **Reclining Figure:
Arch Leg**

**Reclining Figure: Arch
Leg** at the Royal Botanic
Gardens, Kew

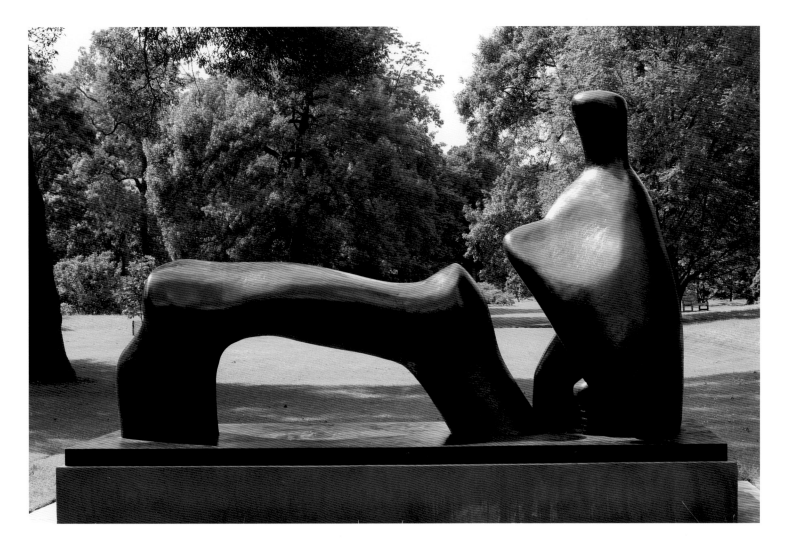

Reclining Connected Forms

1969
LH 612
bronze edition of 9 + 1
cast: Morris Singer, Basingstoke
length 213cm
signature: stamped Moore, 7/9
The Henry Moore Foundation: gift of the artist 1977

**Reclining Connected
Forms** at the Royal Botanic
Gardens, Kew

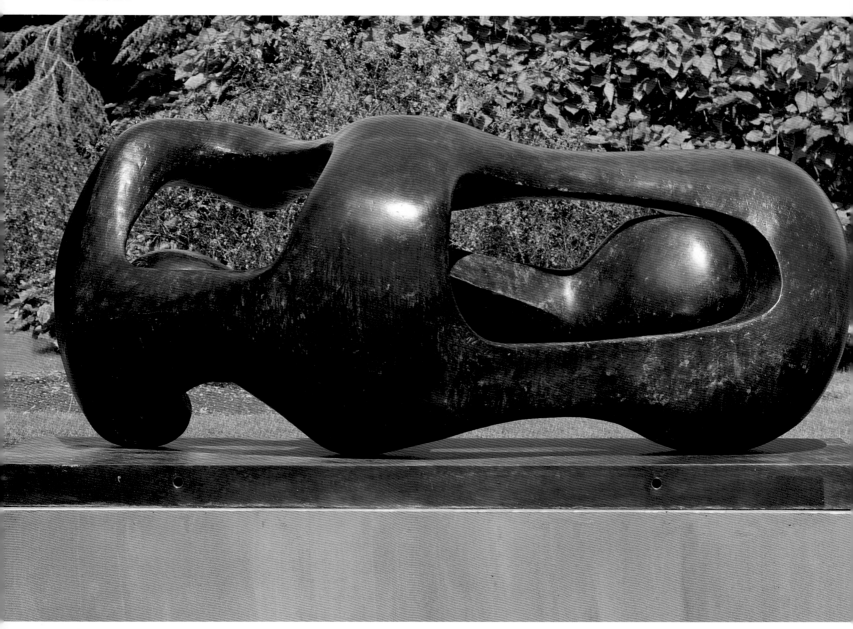

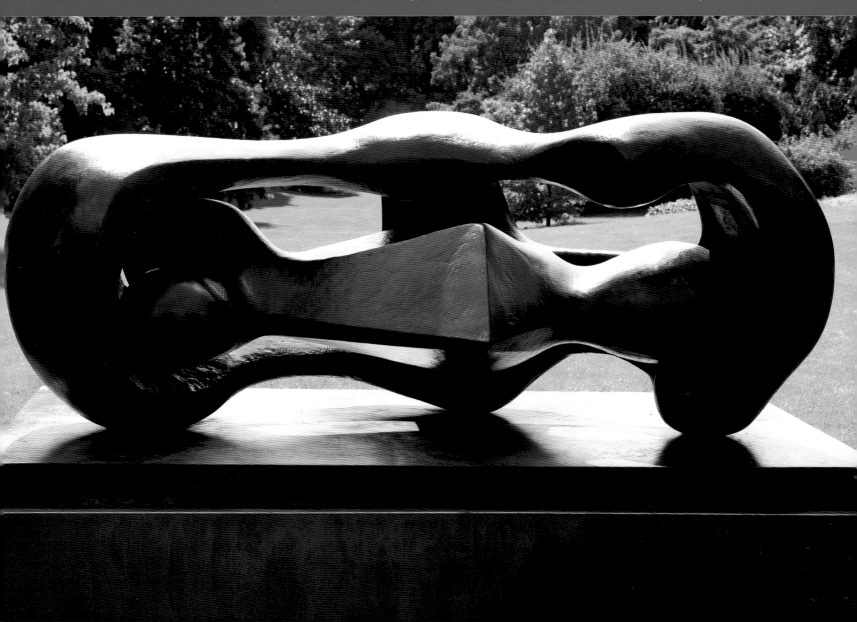

Hill Arches

1973
LH 636
bronze edition of 3 + 1
cast: Hermann Noack, Berlin
length 550cm
signature: stamped Moore, 0/3
The Henry Moore Foundation: gift of the artist 1977

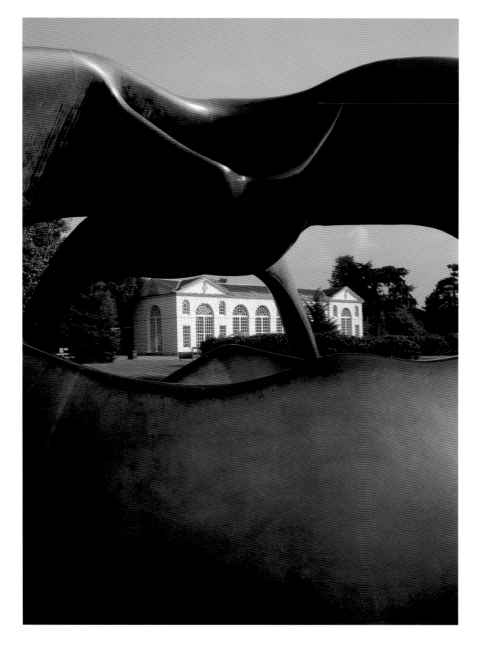

Detail of **Hill Arches** at the
Royal Botanic Gardens, Kew

Hill Arches at the Royal
Botanic Gardens, Kew

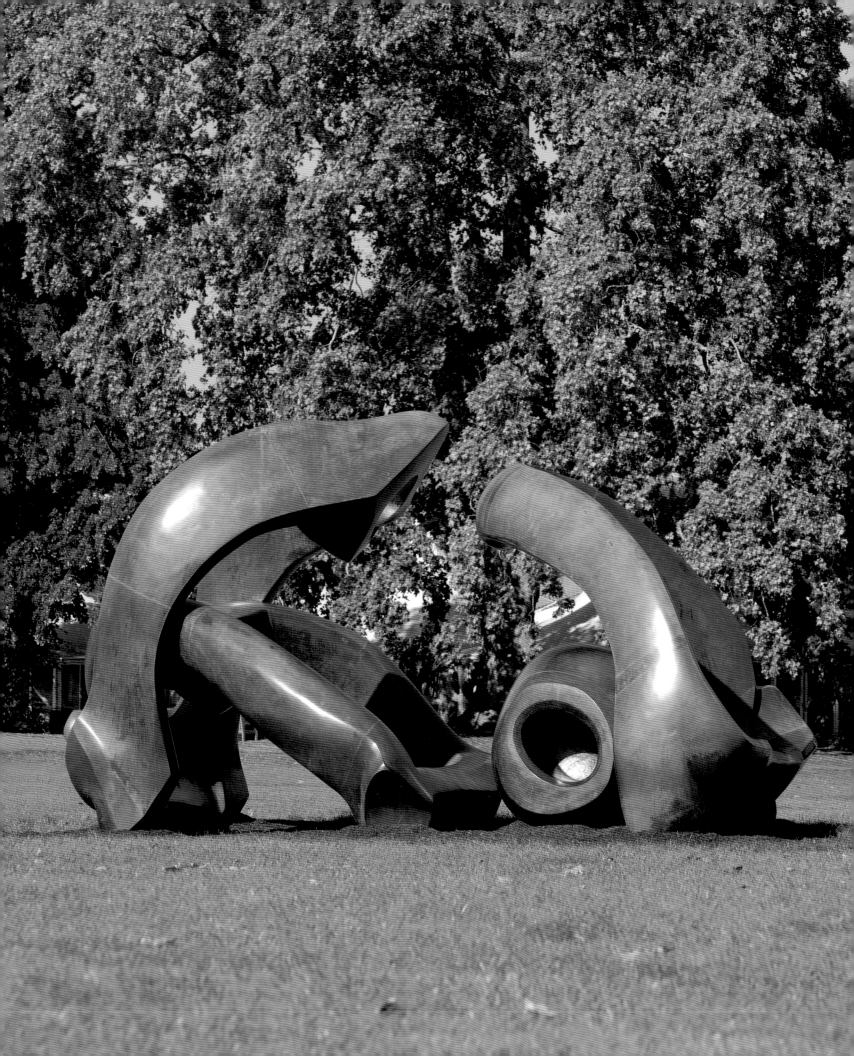

Goslar Warrior

1973–74
LH 641
bronze edition of 7 + 1
cast: Hermann Noack, Berlin
length 300cm
signature: stamped Moore, 0/7
The Henry Moore Foundation: gift of the artist 1977

This falling warrior was being cast by the Noack foundry in Berlin when Moore discovered that he had been nominated for a prestigious art prize awarded by the town of Goslar, northern Germany. On receiving the Kaiserring (Emperor's ring) in 1975 Moore was commissioned to produce a work for Goslar. He chose this piece and sited it himself in the Pfalzgarten (Imperial Palace Garden).

Moore rarely studied the male form, and there are only six life-size male figures amongst his body of work, three of which are warriors. These are not combatants in the traditional sense; none have weapons. This warrior, with his twisted, thin, fallen body, has only one limb, rendering him powerless. His visage has the angular suggestion of a helmet, yet ears are clearly visible, underlining his vulnerability and humanity.

Moore had lived through two world wars. As a nineteen year old during the First World War he was sent to the trenches in northern France and suffered the effects of a mustard gas attack, requiring him to be sent home to convalesce. It can be assumed therefore that he bore witness to death and suffering both at the front line and while recovering in hospital. During the Second World War relentless bombing drove many Londoners to take shelter in the network of tunnels deep underneath the city streets. Moore spent hours observing and making discreet notes of the huddled blanketed people in the London Underground. As a result of the sketches he made Moore was appointed as an official war artist, and later commissioned to produce seventeen large-scale drawings to be displayed in public galleries and museums throughout the UK.

Detail of **Goslar Warrior**

Detail of **Goslar Warrior** in Perry Green

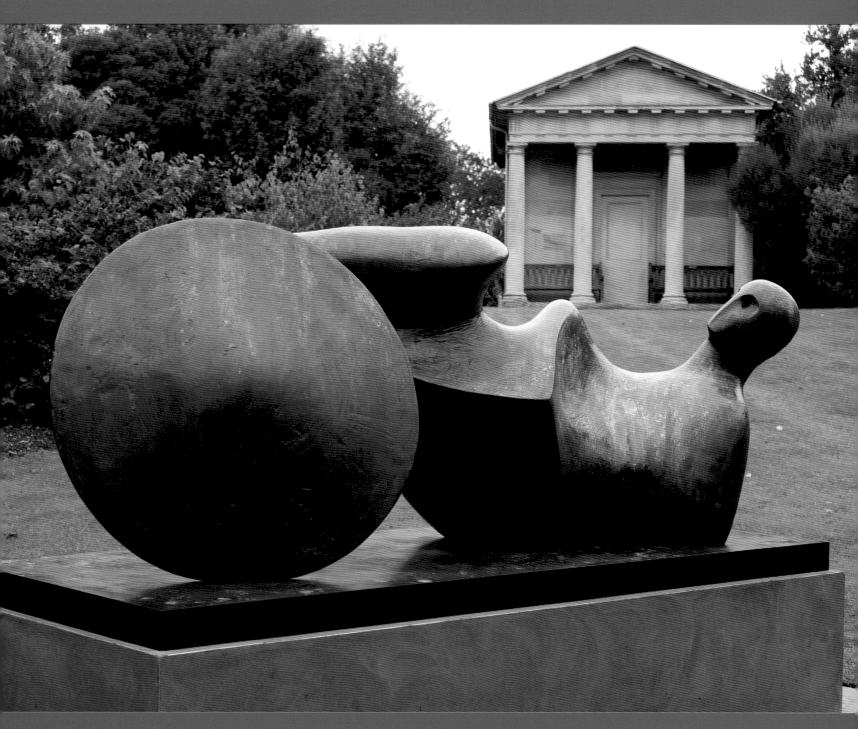

Goslar Warrior at the Royal
Botanic Gardens, Kew

Three Piece Reclining Figure: Draped

1975
LH 655
bronze edition of 7 + 1
cast: Morris Singer, Basingstoke
length 474cm
signature: stamped Moore, 0/7
The Henry Moore Foundation: acquired 1987

"The two and three piece sculptures were experiments and you must experiment. You do things in which you eliminate something which is perhaps essential, but to learn how essential it is you leave it out. The space then becomes very significant . . . If you are doing a reclining figure you just do the head and the legs. You leave space for the body, imagining the other part even though it isn't there. The space then becomes very expressive and you have to get it just right . . ."

Carlton Lake, 'Henry Moore's World', *Atlantic Monthly*, vol.209, no.1, January 1962

Early in his career Moore had experimented with small carvings divided into two, three and four pieces. At the end of the fifties he returned to exploring a division of the whole. This gave him countless possibilities within one figure, allowing him to explore the gap and distance between each form, investigating the negative space around the work on a much deeper level.

Moore's desire to open up the bulk of a sculpture was a continuing quest, beginning with his carving holes in stone or wood, piercing the solid mass to explore the internal space. But working with stone and wood, both being dense and stable, necessitates reverence for the integrity of the internal structure. Bronze has no such limitations. Modelling with clay and then casting in bronze enabled Moore to investigate each form thoroughly, creating openings and outlines, individual elements that together make up the whole.

During his college years, Moore spent many hours in the British Museum and was particularly moved by the solid powerful figures in the ethnographic collection, an area of interest which, unlike Ancient Greek of Renaissance art, did not feature very strongly in the art history teaching at the time.

Between 1949 and 1951 an exhibition of Moore's work toured Europe. Henry and Irina visited Greece in 1950 as the exhibition reached Athens. Moore, captivated by the light, was thoroughly enthused by sites such as the Acropolis and Mycenae. Soon the stimulation of the excursion filtered into his work: several sculptures appear with drapery, including **Draped Reclining Woman** 1957–58, **Reclining Figure: Angles** 1979 (cat.24), and **Draped Reclining Mother and Baby** 1983.

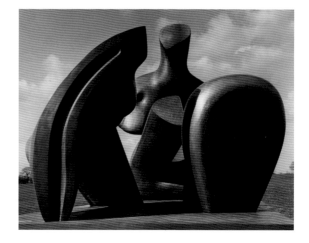

Three Piece Reclining Figure: Draped in Perry Green, Hertfordshire

Three Piece Reclining Figure: Draped at the Royal Botanic Gardens, Kew

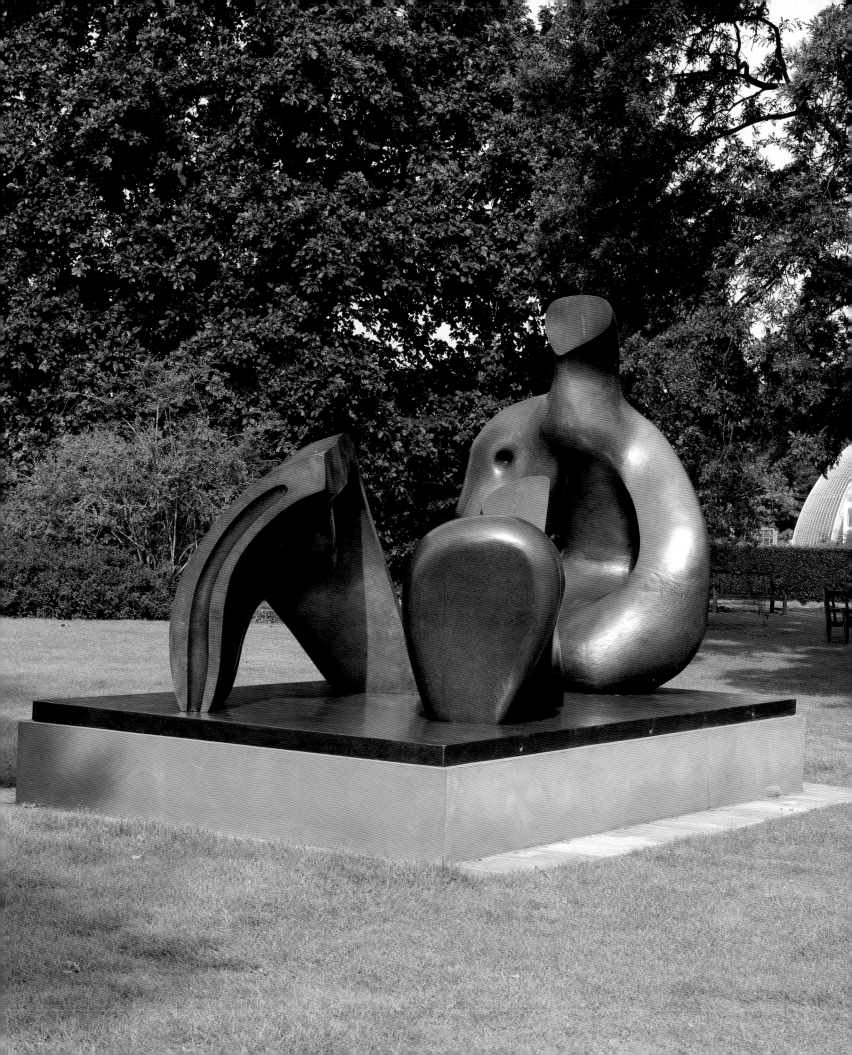

Reclining Figure: Angles

1979
LH 675
bronze edition of 9 + 1
cast: Hermann Noack, Berlin
length 218cm
signature: stamped Moore, 0/9
The Henry Moore Foundation: acquired 1986

Reclining Figure:
Angles at the Royal Botanic
Gardens, Kew

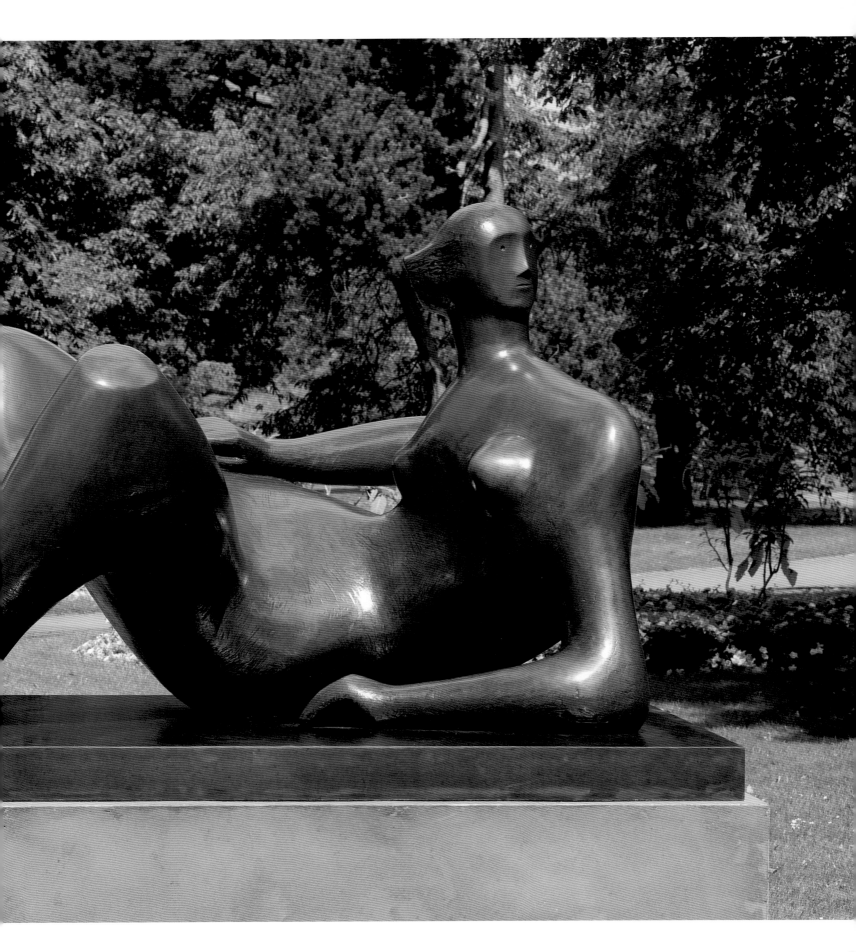

Reclining Figure

1982
LH 677a
bronze edition of 9 + 1
cast: Morris Singer, Basingstoke
length 236cm
signature: stamped Moore, 0/9
The Henry Moore Foundation: acquired 1986

Detail of **Reclining Figure**

Reclining Figure at the
Royal Botanic Gardens, Kew

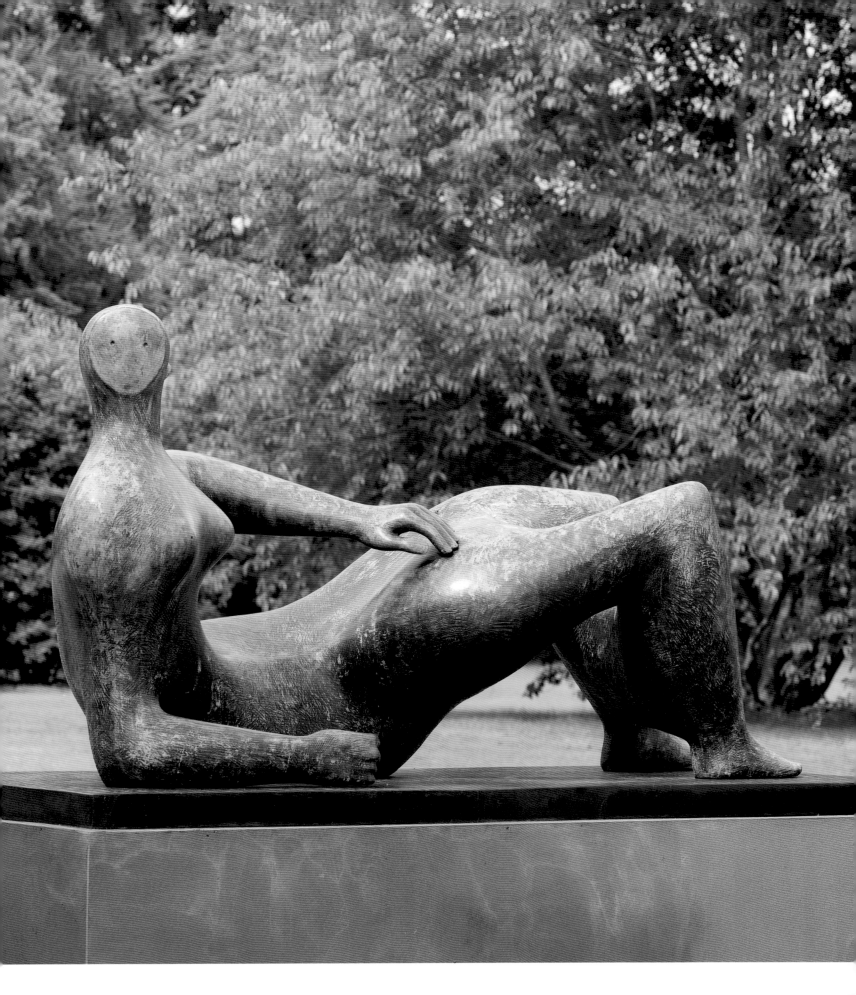

Two Piece Reclining Figure: Cut

1979–81
LH 758
bronze edition of 3 + 2
cast: Hermann Noack, Berlin
length 480cm approx.
unsigned, [0/3]
The Henry Moore Foundation: acquired 1986

The sensual curves of this female form are ruptured by a deep architectural cut. The cut is a surprise, a stark slice through the body, which is juxtaposed alongside the smooth undulating torso. As we move around the figure, our gaze is drawn upwards to her head where we can view a segment of sky through the aperture of her eye.

Moore has delved into the internal spaces of this form twofold, permitting a dialogue with the scenery, inviting the viewer to unfold the work and discover its different angles and aspects. The slim torso features a backbone or long plait, harking back to the human source of this abstract composition.

At the end of the 1970s the Hyatt Foundation in Rosemont, Illinois, purchased the entire edition of the nine maquettes from which this work derived. Later renamed **Architectural Prize** 1979 (LH 756), the maquettes were awarded as the Pritzker Architecture prize to living architects whose work consistently and significantly contributed to humanity and the built environment. The first recipient was Philip Johnson, a friend of Moore's, and later winners included Gordon Bunshaft, Sir Norman Foster, Frank Gehry and Oscar Niemeyer.

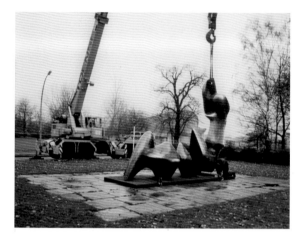

Installation of **Two Piece Reclining Figure: Cut** City of Strasbourg

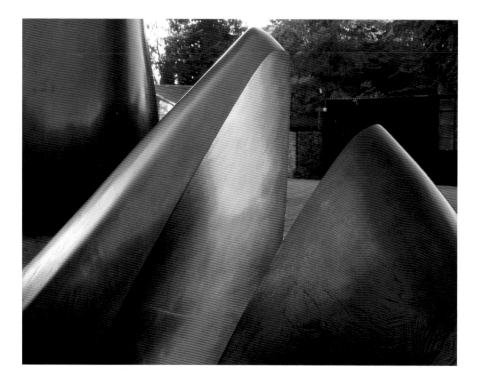

Detail of **Two Piece Reclining Figure: Cut** taken at sunset in Perry Green

Two Piece Reclining Figure: Cut at the Royal Botanic Gardens, Kew

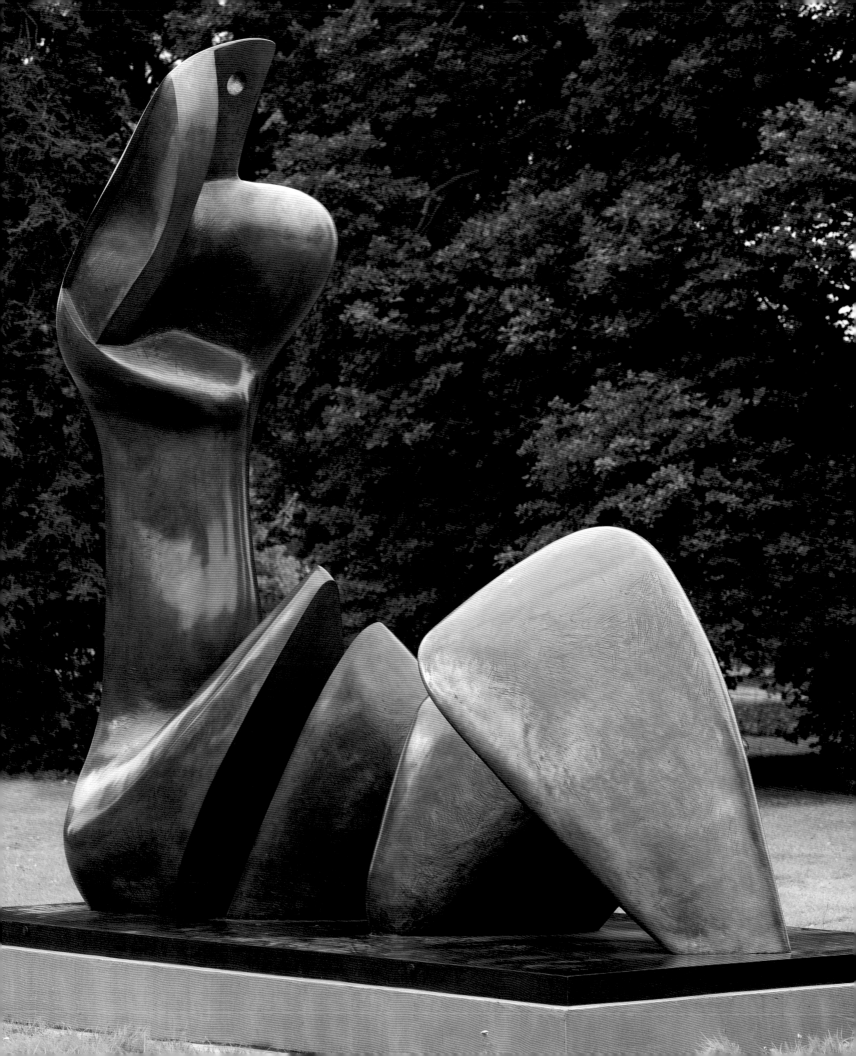

Draped Reclining Mother and Baby

1983
LH 822
bronze edition of 9 + 1
cast: Morris Singer, Basingstoke
length 265.5cm
signature: stamped Moore, 0/9
The Henry Moore Foundation: acquired 1986

**Draped Reclining Mother
and Baby** at the Royal
Botanic Gardens, Kew

Details of **Draped Reclining
Mother and Baby**

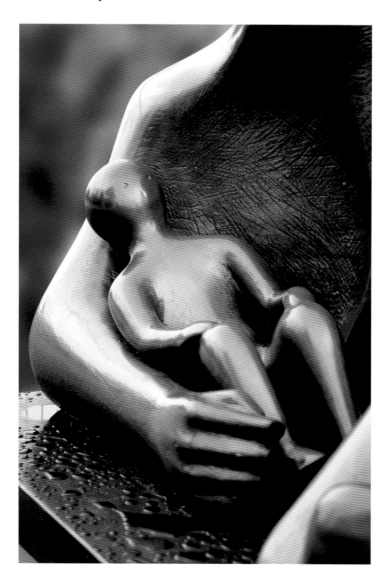

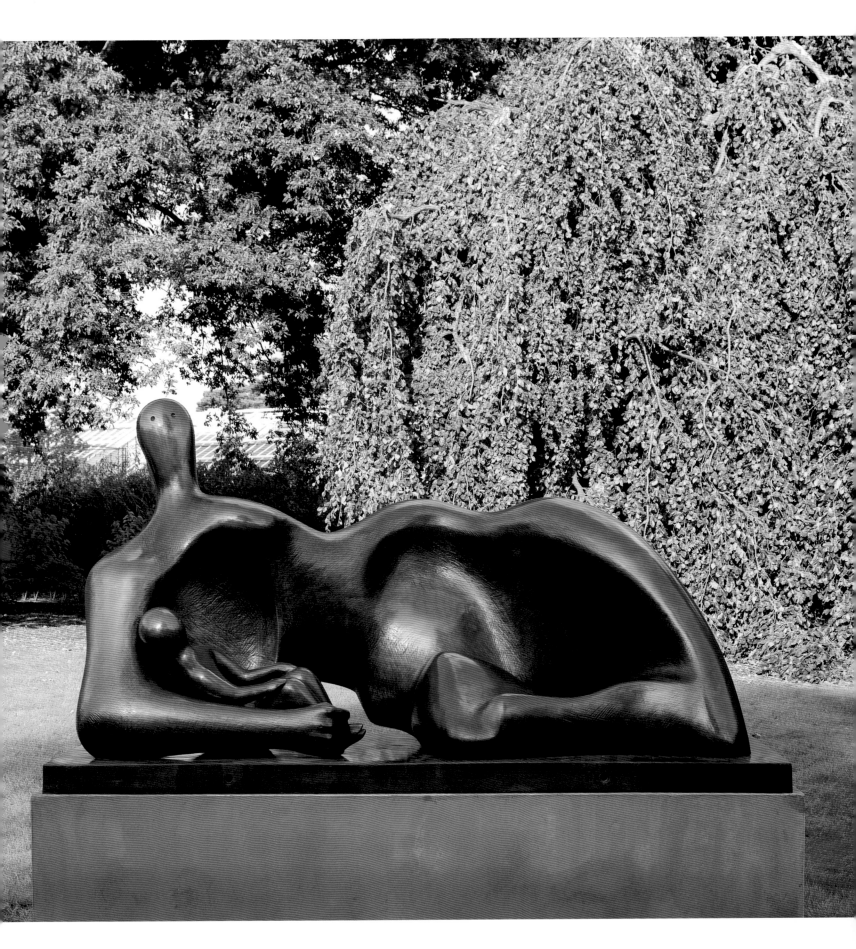

Mother and Child: Block Seat

1983–84
LH 838
bronze edition of 9 + 1
cast: Morris Singer, Basingstoke
height 244cm
signature: stamped Moore, 0/9
The Henry Moore Foundation: acquired 1986

> "The 'Mother and child' idea is one of my two or three obsessions, one of my inexhaustible subjects . . . But the subject itself is eternal and unending, with so many sculptural possibilities in it – a small form in relation to a big form protecting the small one, and so on. It is such a rich subject, both humanly and compositionally, that I will always go on using it."

Henry Moore Drawings 1969–79, Wildenstein, New York 1979, p.29.

The mother and child theme was, by Moore's own admission, one of his 'inexhaustible subjects', resurfacing again and again in his work, sometimes explicitly and at other times implicitly, as with the internal/external forms.

Maquette for Mother and Child: Block Seat (LH 836) was produced in 1981 and the full-size version cast in 1983–4, by which time Moore had two young grandchildren.

There is a psychological connection between the figures, the mother's head tilted towards the infant in her arms implying an intimate gaze. Her stable, sturdy body gently supports the bud-like newborn. The division of the solid mass into two forms, inferring a connection between the pieces, is another enduring aspect of Moore's work – he explores the importance of space, as each form relates to the other, suggesting protection, confinement and closeness. A more representational version of the maternal bond is seen in **Draped Reclining Mother and Baby** 1983, a curvaceous, lounging mother with a playful toddler nestled in her arm.

Large Upright Internal/External Form 1981–82 is a departure from the figurative, showing the slight and graceful inner being cocooned by the large outer figure.

Plaster working model and maquette for **Mother and Child: Block Seat**, Perry Green

Detail of **Mother and Child: Block Seat** at Yorkshire Sculpture Park

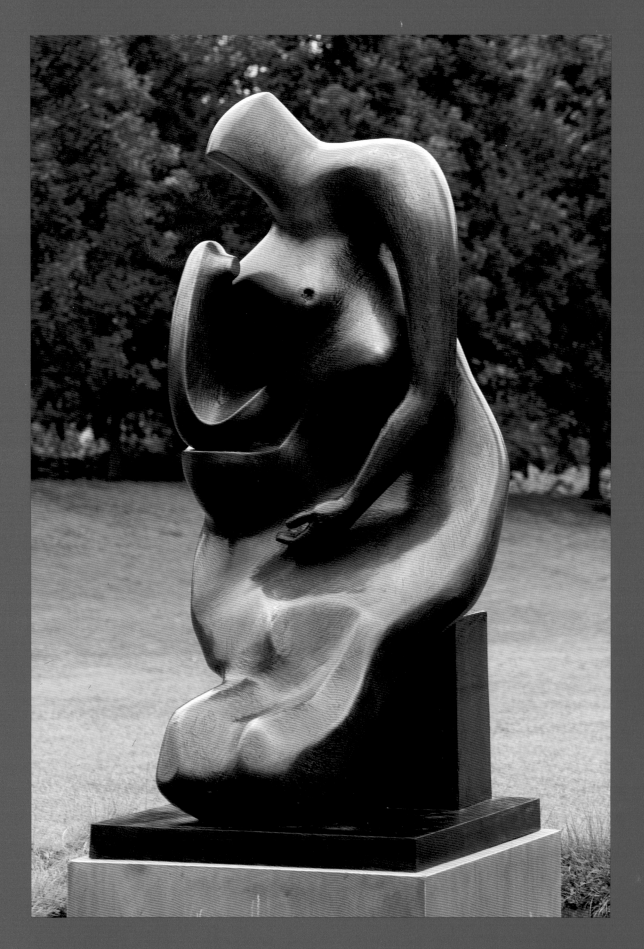

**Mother and Child: Block
Seat** at the Royal Botanic
Gardens, Kew

A chronology of Moore's life and work

30 July 1898
Henry Spencer Moore is born, the seventh of eight children, in Castleford, Yorkshire, where his father is a miner.

Henry Moore aged 14–15

1917
Enlists in the Civil Service Rifles, 15th London Regiment and serves in First World War; is gassed at the Battle of Cambrai and returns to England to convalesce.

1919–20
Enrols at Leeds School of Art, where a sculpture department is set up with Moore as the sole student.

1921
Wins a scholarship to study sculpture at the Royal College of Art, London. Begins frequent visits to the British Museum where he fills sketchbooks with studies of sculpture from around the world.

1922
Develops his interest in direct carving and in the work of Henri Gaudier-Brzeska and Constantin Brancusi. Visits Paris, where he is deeply impressed by Paul Cézanne's paintings in the Auguste Pellerin collection. His family moves to Norfolk, where during vacations Moore makes his first carvings.

1924
Takes part in his first group exhibition at the Redfern Gallery, London. Appointed instructor in the sculpture department at the Royal College of Art. Rents work space at 3 Grove Studios, Hammersmith.

Henry Moore with Norman Douglas on a travelling scholarship to Rome 1925

1925
Travelling scholarship takes him, via Paris, to Rome, Florence, Pisa, Siena, Assisi, Padua, Ravenna and Venice.

1928
His first one-man exhibition is held at the Warren Gallery, London; drawings bought by Jacob Epstein and Augustus John. Meets Irina Radetsky, a painting student at the Royal College.

1929
Moore and Irina are married; they move to Hampstead, which becomes a centre for artists, architects and writers in the 1930s including Naum Gabo, Piet Mondrian, Walter Gropius, Marcel Breuer, Laszlo Moholy-Nagy, Ben Nicholson and Barbara Hepworth. Carves the Hornton stone Reclining Figure now in Leeds City Art Gallery, completes West Wind, a relief in Portland stone on the Headquarters of the London Underground, St James's Park.

1930
Exhibits with the Young Painters' Society and the London Group; chosen (with Epstein and John Skeaping) to represent Britain at the Venice Biennale.

1931
Resigns from his teaching post at the Royal College of Art. Following a one-man exhibition at the Leicester Galleries, London, his first work is sold abroad, to a museum in Hamburg. Becomes first head of sculpture in new department at Chelsea School of Art. Buys a cottage in Kent where he can carve in the open-air.

1932
Completes twenty carvings in wood and stone, including **Mother and Child** (LH 121), now in the Sainsbury Centre for Visual Arts, UEA, Norwich.

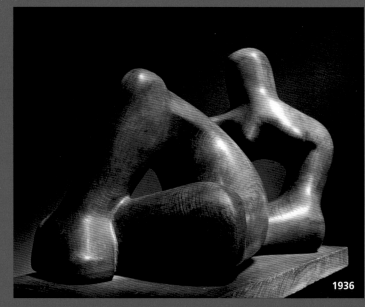

Reclining Figure 1936
(LH 175) elmwood

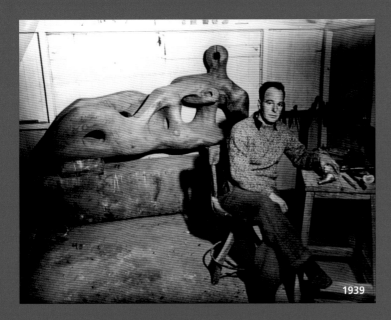

Moore in Burcroft studio
with **Reclining Figure** 1939
(LH 210) elmwood

1933
Second exhibition at the Leicester
Galleries, London. Chosen to
become a member of Unit One,
a group of avant-garde artists.
In Paris he meets Alberto
Giacometti, Ossip Zadkine and
Jacques Lipchitz.

1934
Travels with Irina and friends to
see prehistoric cave paintings in
Altamira, Spain and Les Eyzies de
Tayac, France. In Spain, Moore
also visits Barcelona, Madrid
and Toledo. The first monograph
on his work, by Herbert Read,
is published.

1935
Buys a larger cottage with land
near Canterbury, Kent, where he
makes many carvings in the open
air. As the size of his carvings
increases he makes use of
small preliminary models, known
as maquettes.

1936
Finishes his first major elmwood
carving, **Reclining Figure**
(LH 175), now in Wakefield City
Art Gallery. Serves on the
Organising Committee of the
International Surrealist Exhibition
at the New Burlington Galleries,
London, in which he also takes
part. Signs the Surrealist manifesto.

1937
Begins a series of stringed figures
inspired by mathematical models
in the Science Museum, London.
Accompanies Roland Penrose to
Paris, and with Giacometti, Paul
Eluard, André Breton and Max
Ernst, visits Picasso in his studio
to see *Guernica* in progress.

1939
On the outbreak of war he is
forced to give up his post when
Chelsea School of Art closes, as
well as his cottage in Kent as the
area is evacuated due to threat of
invasion; draws **September 3rd,
1939** of bathers near the Dover
cliffs the day war is declared;
produces his first lithograph,
Spanish Prisoner (CGM 3),
intended to be sold in aid of
Spanish prisoners of war.

1940
He and Irina move to Perry Green,
Hertfordshire, when their London
home and studio is damaged
during an air-raid. Begins **Shelter
Drawings** of figures in the London
Underground during the Blitz.

1942
Commissioned by the War
Artists' Advisory Committee to
make a series of drawings of
coalminers at Wheldale Colliery,
near Castleford, the mine in
which his father had worked.

1944
Madonna and Child (LH 226)
is installed in St Matthew's
Church, Northampton.

1946
Birth of the Moores' only
child, Mary.

1948
Represents Britain at the XXIV
Venice Biennale, where he is
awarded the International Prize for
Sculpture. Begins work on **Family
Group** (LH 269) for a local school
in Stevenage – perhaps surprisingly
this and **Harlow Family Group**

1955 (LH 364) would be the only
family group sculptures to be
developed life size.

1950
Moore refuses the offer of
a knighthood.

1951
Moore's first retrospective at the
Tate Gallery; **Reclining Figure:
Festival** (LH 293) is exhibited
on the South Bank during the
Festival of Britain. He tours
Greece on the occasion of his
exhibition in Athens.

1952
A period of intense sculptural
activity includes a series of
standing figures, internal/external
forms and reliefs; work begins on
two sculptures for the Time-Life
Building in Bond Street, and **King
and Queen** (LH 350) all three
completed the following year.

Madonna and Child
1943–44 (LH 226) being
transported outside St Matthews
Church, Northampton

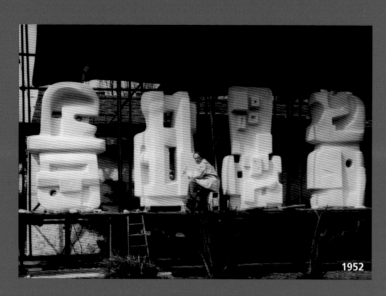

1952

Moore in front of the four main components of the screen for Michael Rosenauer's Time/Life Building, on scaffolding outside Hoglands

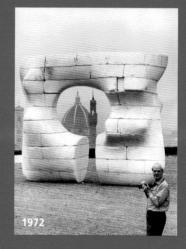

1972

Moore at Forte di Belvedere, Florence 1972, with polystyrene **Large Square Form with Cut** (LH 599) in progress

1953
Moore attends the 2nd São Paulo Bienal, where he is awarded the International Sculpture Prize; afterwards he tours Brazil and Mexico.

1955
Makes a series of Upright Motives. Appointed Member of the Order of the Companions of Honour; made a Trustee of the National Gallery, London (1955–74).

1956
Receives a sculpture commission for Marcel Breuer's UNESCO headquarters in Paris.

1958
Moore is appointed Chairman of the Auschwitz Memorial Committee.

1959
Begins large elmwood **Reclining Figure** (LH 452) and completes the bronze **Two Piece Reclining Figure No.1** (LH 457) the first in a series of sculptures that fragment the figure to resemble landscape.

1965
Completes **Knife Edge Two Piece** (LH 516), a cast of which is sited outside the Houses of Parliament in Westminster. Visits New York for the installation of **Reclining Figure** (LH 519) at Lincoln Center. Buys a house in Forte dei Marmi, where he and his family spend subsequent summer holidays.

1967
Attends the unveiling of **Nuclear Energy** (LH 526) on the University of Chicago campus. Is created Honorary Doctor, Royal College of Art, London, and Fellow of the British Academy.

1968
A retrospective at the Tate Gallery, London, marks Moore's seventieth birthday; at an exhibition at the Rijksmuseum Kröller-Müller, Otterlo, he receives the Erasmus Prize. Awarded the Order of Merit by the Federal Republic of Germany, and the Einstein Prize by Yeshiva University, New York. Begins work on monumental bronze **Three Piece Sculpture: Vertebrae** (LH 580).

1972
A spectacular retrospective exhibition is held at the Forte di Belvedere, Florence; Moore attends the opening by HRH The Princess Margaret, and later presents a cast of **Warrior with Shield** (LH 360) to the city of Florence. Begins drawing the Sheep Sketchbook, which in turn leads to an album of sheep etchings.

1974
Inauguration of the Henry Moore Sculpture Centre at the Art Gallery of Ontario, Toronto, to which Moore donates 101 sculptures, 57 drawings and an almost complete collection of lithographs and etchings.

1977
Inauguration of the Henry Moore Foundation. Exhibition at the Orangerie des Tuileries, Paris.

1978
Moore's eightieth birthday is marked by exhibitions at the Tate Gallery and Serpentine Gallery in London, and the City Art Gallery, Bradford. He makes a gift of thirty-six sculptures to the Tate. **Mirror: Knife Edge** (LH 714) installed at the National Gallery of Art, Washington DC.

1979

Now suffering from arthritis in his hands and finding sculpting difficult, Moore devotes more time to drawing and graphic work; makes series of etchings and lithographs of trees and hands.

1980

Moore's tapestries are exhibited at the Victoria and Albert Museum, London. A large marble version of **The Arch** (LH 503c) is donated to the Department of the Environment (now Royal Parks) for Kensington Gardens. Moore is awarded the Grand Cross of the Order of Merit of the Federal Republic of Germany. Despite declining health, he completes 350 drawings.

1982

The Henry Moore Sculpture Gallery and Centre for the Study of Sculpture (now Henry Moore Institute) is opened by HM The Queen as an extension to Leeds City Art Gallery.

1984

Created Commandeur de l'Ordre National de la Légion d'Honneur when President Mitterrand visits him at Perry Green. A touring exhibition of war drawings opens at the Nationalgalerie in East Berlin.

1985

Moore creates **Large Figure in a Shelter** (LH 652c) for Peace Park in Guernica.

31 August 1986

Moore dies at Perry Green, aged 88. A Service of Thanksgiving for his life and work is held on 18 November in Westminster Abbey.

1982

Moore meeting Her Majesty the Queen at the inauguration of the Henry Moore Centre for the Study of Sculpture, Leeds City Art Gallery

1978

Henry Moore's Eightieth Birthday Exhibition, Moore pictured with Philip King and Anthony Caro

Bibliography

Bibliography

The Henry Moore Bibliography. Vol.1
1898–1986. Vol.2 1971–1986. Vol.3 Index
1898–1986. Vol.4 1986–1991. Vol 5 Index
1898–1991, ed. Alexander Davis. Henry Moore
Foundation, London and Much Hadham.

Catalogue raisonnés

Henry Moore: Complete Sculpture. Vol.1
1921–48 (entitled *Sculpture and Drawings*), ed.
Herbert Read 1944, 4th revised edition ed.
David Sylvester 1957. Vol.2 1949–54, ed.
David Sylvester 1955, 3rd revised edition ed.
Alan Bowness 1986. Vol.3 1955–64, ed. Alan
Bowness 1965, 2nd revised edition 1986. Vol.4
1964–73, ed. Alan Bowness 1977. Vol.5
1974–80, ed. Alan Bowness 1983, 2nd revised
edition 1994. Vol.6 1981–86, ed. Alan
Bowness 1988. Lund Humphries, London.

Henry Moore: Catalogue of Graphic Work.
[Vol.I] 1931–72, ed. Gérald Cramer, Alistair
Grant and David Mitchinson 1973. Vol.II
1973–75, ed. Gérald Cramer, Alistair Grant and
David Mitchinson 1976. Vol.III 1976–79, ed.
Patrick Cramer, Alistair Grant and David
Mitchinson 1980. Vol.IV 1980–84, ed. Patrick
Cramer, Alistair Grant and David Mitchinson
1988. Cramer, Geneva.

Henry Moore: Complete Drawings. Vols. 1–7,
ed. Ann Garrould, The Henry Moore
Foundation in association with Lund
Humphries, London, 1977–2003.

Books

Andrews, Julian: *London's War: The Shelter
Drawings of Henry Moore*, Lund Humphries,
Aldershot 2002

Berthoud, Roger, *The Life of Henry Moore*,
Faber, London 1987; revised edition Giles de la
Mare, London 2003

Lewison, Jeremy, *Moore*, Taschen,
Cologne, 2007

Mitchinson, David, *Celebrating Moore*, *Works
from the Collection of the Henry Moore
Foundation* selected and introduced by David
Mitchinson with contributions from Julian
Andrews, Roger Berthoud, Giovanni
Carandente, Frances Carey, Anthony Caro,
David Cohen, Susan Compton, Richard Cork,
Penelope Curtis, Deborah Emont-Scott, Anita
Feldman Bennet, Terry Friedman, Gail Gelburd,
Clare Hillman, Phillip King, Christa Lichtenstern,
Norbert Lynton, Bernard Meadows, Peter
Murray, William Packer, John Read, Reinhard
Rudolph, Julian Stallabrass, Julie Summers, Alan
Wilkinson; Lund Humphries, London 1998

Wilkinson, Alan, *Henry Moore Writings and
Conversations*, Lund Humphries, Aldershot 2002

An Introduction to Henry Moore, The Henry
Moore Foundation, Much Hadham 2002,
reprinted 2005

Henry Moore's Sheep Sketchbook, comments
by Henry Moore and Kenneth Clark, Thames
and Hudson, London and New York 1980;
revised edition 1998

Sculpture in the Open Air at Perry Green, The
Henry Moore Foundation, Much Hadham 1999

Exhibition catalogues

Henry Moore: In the Light of Greece, essays by
Anita Feldman Bennet and Roger Cardinal,
Museum of Contemporary Art, Andros, Basil &
Elise Goulandris Foundation 2000

Moore in China, text by David Mitchinson, The
British Council, London and the Henry Moore
Foundation, Much Hadham 2000

Henry Moore: War and Utility, text by David
Mitchinson, The Henry Moore Foundation,
Much Hadham 2001

Henry Moore rétrospective, essays by Anita
Feldman Bennet, Caroline Edde, Jean-Louis Prat
and Margaret Reid, Fondation Maeght, Saint
Paul de Vence 2002

Henry Moore: Imaginary Landscapes, text by
Anita Feldman Bennet, The Henry Moore
Foundation, Much Hadham 2003

Moore: The Graphics, texts by Anita Feldman
Bennet and David Mitchinson, The Henry
Moore Foundation, Much Hadham 2003

Henry Moore: A Living Presence, essays by
Anita Feldman Bennet and Koji Takahashi, Artis
Inc, Tokyo 2003

*Master Drawings from the Collection of the
Henry Moore Foundation*, Hazlitt Holland-
Hibbert, London 2004

Henry Moore, essays by Anita Feldman Bennet,
Ian Dejardin and Anne Garrould, Dulwich
Picture Gallery; Scala, London 2004

*Six Leading Sculptors and the Human Figure:
Rodin, Bourdelle, Maillol, Brancusi, Giacometti,
Moore*, essays by Anita Feldman Bennet,
Véronique Gautherin, Doïna Lemny, Bertrand
Lorquin, Antoinette le Normand-Romain, Mary
Lisa Palmer; National Gallery – Alexandros
Soutzos Museum, Athens 2004

*Henry Moore: Human Landscapes/Menschliche
Landschaften*, essays by Christa Lichtenstern
and Sabine Maria Aschmidt, Kerber Verlag,
Bielefeld 2004

Henry Moore and the Challenge of Architecture, text by Anita Feldman Bennet, The Henry Moore Foundation, Much Hadham 2005

Henry Moore: Uma Retrospectiva, essays by Aracy Amarel, Anita Feldman Bennet, Rafael Cadoso, David Mitchinson and Margaret Reid, Pinacoteca do Estado de São Paulo; Paço Imperial, Rio de Janeiro; Centro Cultural Banco de Brasil, Brasília 2005

Henry Moore: Epoche und Echo/Englische Bildhauerei im 20. Jahrhundert, essays by Ian Barker and Christa Lichtenstern, Swiridoff, Würth 2005

Henry Moore y Mexico, text by Toby Treves, Tate, and Museo Dolores Olmedo, Mexico City 2005

Henry Moore: Sculptuur en architectuur, essays by Anita Feldman Bennet, Jan van Adrichem and Suzanne Eustace, Terra, Rotterdam 2006

Henry Moore essays by Anita Feldman Bennet, Maria Luisa Borràs and Toby Treves, Fundació 'la Caixa', Barcelona 2006

Moore and Mythology, text by David Mitchinson, The Henry Moore Foundation, Much Hadham 2007

Hoglands: The Home of Henry and Irina Moore ed. David Mitchinson, essays by Anita Feldman Bennet, Andrew Causey, Martin Davis, Anne Garrould, Mary Moore, Michael Phipps, Lund Humphries, London 2007

Henry Moore und die Landschaft, essays by Anita Feldman Bennet, Katja Blomberg, Beate Kemfert, Helmut Schmidt and Irene Tobbin, Haus am Waldsee, Berlin, Opelvillen Rüsselheim and DuMont Literatur und Kunst Verlag, Cologne 2007

Moore working on the polystyrene for **Working Model for Spindle Piece** 1968–69 (LH 592)

Acknowledgements

The Trustees of the Royal Botanic Gardens, Kew would like to thank:

The Henry Moore Foundation, for the loan of their inspirational sculptures and the enthusiasm and support of their trustees.

Curators: David Mitchinson and Anita Feldman of the Henry Moore Foundation in collaboration with Laura Giuffrida of Kew.

Co-ordination: Charlotte Booth of the Henry Moore Foundation and David Yard of Kew.

Installation: James Copper, John Farnham, Laura Robinson and Malcolm Woodward, expertly aided by the team at Momart.

Appreciation is also due to the following staff of the Henry Moore Foundation who provided educational, research and technical support: Jason Bayford, Martin Davis, Suzanne Eustace, Georgina Gauntlett, Pru Maxfield, Michael Phipps, Geoff Robinson, Emma Stower, Rosemary Walker.

We are especially grateful to the Trustees of The Gatsby Charitable Foundation for their generous grant, without which this exhibition would have been impossible within current financial constraints.

Media sponsor, J C Decaux, who provided extraordinarily valuable advertising space to promote the exhibition in the UK.

The Robert Horne Paper Company and B.A.S. Printers, for their kind support in producing this catalogue.

Above all, the Trustees would like to thank all the members of Kew staff who committed thought, time, effort and energy to help make this exhibition a success.

Photography credits